Remembering
Arizona

Linda and Dr. Dick Buscher

TURNER
PUBLISHING COMPANY

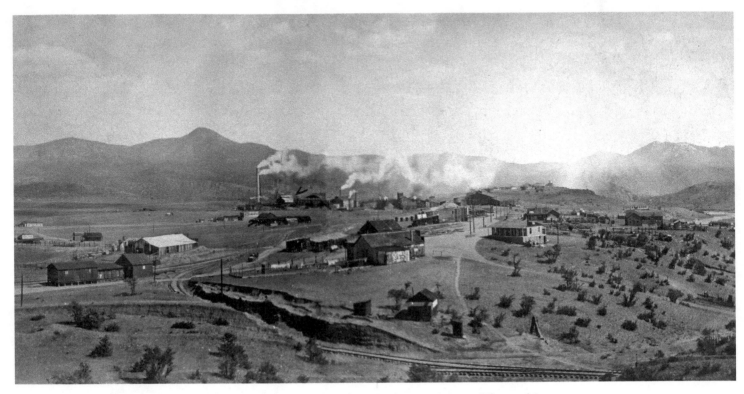

No frontier town in America has more legends and historic lore than Tombstone, Arizona. The mythic "town too tough to die" has fed America's hunger for stories of the Wild West for over 100 years. At least a dozen television shows and movies have been produced concerning the famous Gunfight at the OK Corral, which took place in Tombstone on October 26, 1881. Some of the most famous outlaws and lawmen of the Old West walked the streets of Tombstone during the 1880s.

Remembering
Arizona

Turner Publishing Company
www.turnerpublishing.com

Remembering Arizona

Copyright © 2010 Turner Publishing Company

Library of Congress Control Number: 2010932639

ISBN: 978-1-59652-713-3

Printed in the United States of America

ISBN 978-1-68336-805-2 (pbk.)

CONTENTS

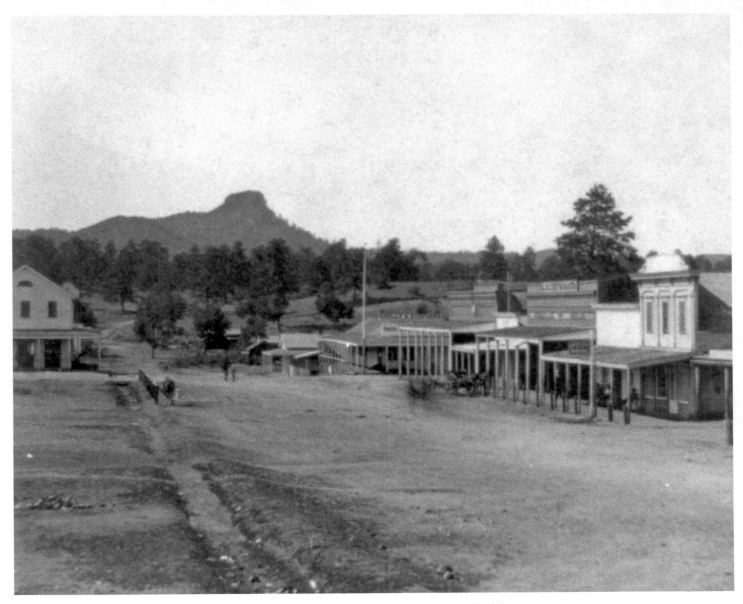

This view is facing west on Gurley Street in Prescott in 1877 when Prescott was the capital of the Territory of Arizona. Prescott citizens believed their town would remain the territorial capital and someday become a state capital. Little did they know that the legislators of Tucson and Phoenix would band together and move the territorial capital to Phoenix in 1889. The mountain in the background is Thumb Butte, a favorite hiking destination then and now.

Acknowledgments

This volume, *Remembering Arizona*, is the result of the cooperation and efforts of many individuals, organizations, and corporations. It is with great thanks that we acknowledge the valuable contribution of the following for their generous support:

Library of Congress
Arizona State Library, Archives and Public Records, History and Archives Division, Phoenix

———————

We would like to thank our lifelong Arizona traveling companions and friends Teresa and Ken Jackway. Without their support and thirst for adventure, our knowledge and love of Arizona would be incomplete, and so our lives less blessed.

In special memory of our beloved cat, Valentino, who we lost while completing this book. We sure did love that cat!

PREFACE

Arizona has thousands of historic photographs that reside in archives, both locally and nationally. This book began with the observation that, while those photographs are of great interest to many, they are not easily accessible. During a time when Arizona is looking ahead and evaluating its future course, many people are asking, How do we treat the past? These decisions affect every aspect of the city—architecture, public spaces, commerce, infrastructure—and these, in turn, affect the way that people live their lives. This book seeks to provide easy access to a valuable, objective look into the history of Arizona.

The power of photographs is that they are less subjective than words in their treatment of history. Although the photographer can make subjective decisions regarding subject matter and how to capture and present it, photographs seldom interpret the past to the extent textual histories can. For this reason, photography is uniquely positioned to offer an original, untainted look at the past, allowing the viewer to learn for himself what the world was like a century or more ago.

This project represents countless hours of review and research. The researchers and writers have reviewed thousands of photographs in numerous archives. We greatly appreciate the generous assistance of the organizations listed in the acknowledgments of this work, without whom this project could not have been completed.

The goal in publishing this work is to provide broader access to this set of extraordinary photographs that seek to inspire, provide perspective, and evoke insight that might assist people who are responsible for determining Arizona's future. In addition, the book seeks to preserve the past with adequate respect and reverence.

With the exception of touching up imperfections that have accrued with the passage of time and cropping where necessary, no changes have been made. The focus and clarity of many images are limited to the technology and the ability of the photographer at the time they were recorded.

The work is divided into eras. Beginning with some of the earliest known photographs of Arizona, the first section records photographs through the end of the nineteenth century. The second section spans the beginning of the twentieth century through World War I. Section Three moves from the 1920s through the 1930s. The last section covers the World War II era to recent times.

In each of these sections we have made an effort to capture various aspects of life through our selection of photographs. People, commerce, transportation, infrastructure, religious institutions, and educational institutions have been included to provide a broad perspective.

We encourage readers to reflect as they go walking in Arizona, strolling through its parks, its countryside, and the neighborhoods of its cities. It is the publisher's hope that in utilizing this work, longtime residents will learn something new and that new residents will gain a perspective on where Arizona has been, so that each can contribute to its future.

—Todd Bottorff, Publisher

The dream of striking it rich has been a part of Arizona's story since the first Spanish conquistadors arrived. For the vast majority of treasure seekers, prospecting in the rugged wilderness of Arizona ended in failure. Some, like this explorer photographed on his way to Arizona's "diamond fields," sought riches that existed only in the made-up stories of other men. The diamond fields of Arizona were a hoax of the early 1870s.

Wild West Territory

(1870–1899)

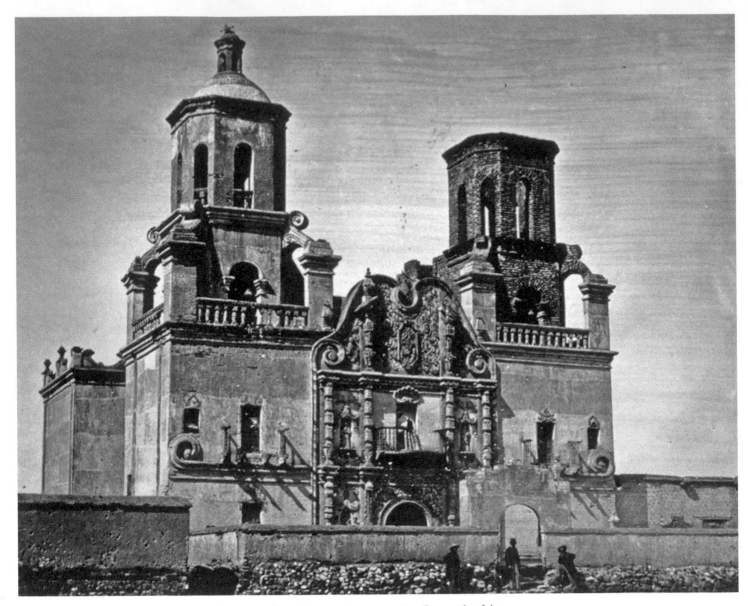

San Xavier del Bac is located on the Tohono O'odham Reservation some 10 miles south of downtown Tucson. The great Jesuit priest Eusebio Francisco Kino first visited the native people of Bac in 1692, hoping to move his missionary headquarters there. Photographed around 1870, this church was constructed by Franciscan priests between 1783 and 1797 and is still a living church today, serving the people of the Tohono O'odham Nation and thousands of visitors.

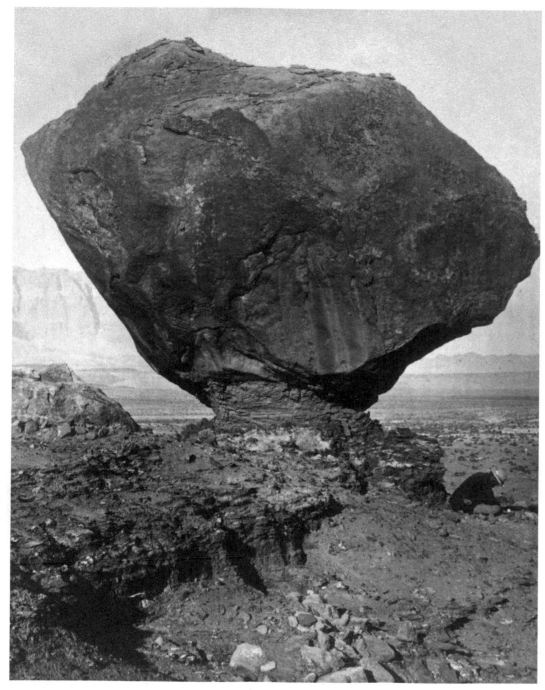

From 1869 to 1879, a U.S. Army Corps of Engineers unit under the supervision of Lieutenant George M. Wheeler completed geographical surveys of the United States west of the 100th meridian. Their object was to record the region's people, flora, fauna, geological wealth, and rail and road routes, and to identify possible sites for future military forts. Survey party photographer William Bell took this picture of a wind-weathered rock found in 1872 in northwestern Arizona.

A family group of Apaches stand in front of their wickiup shelter to be photographed by Timothy O'Sullivan somewhere in southeastern Arizona in 1873. Being a nomadic people, Apache families could quickly build their wickiup shelters from local flora and then simply abandon them when moving to the next home site. O'Sullivan, a famous Civil War photographer, participated in Wheeler's survey of the regions west of the 100th meridian from 1871 to 1874.

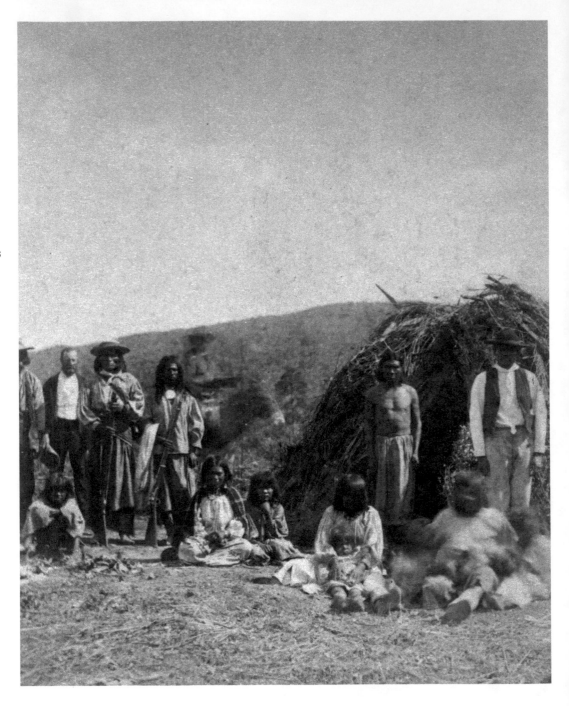

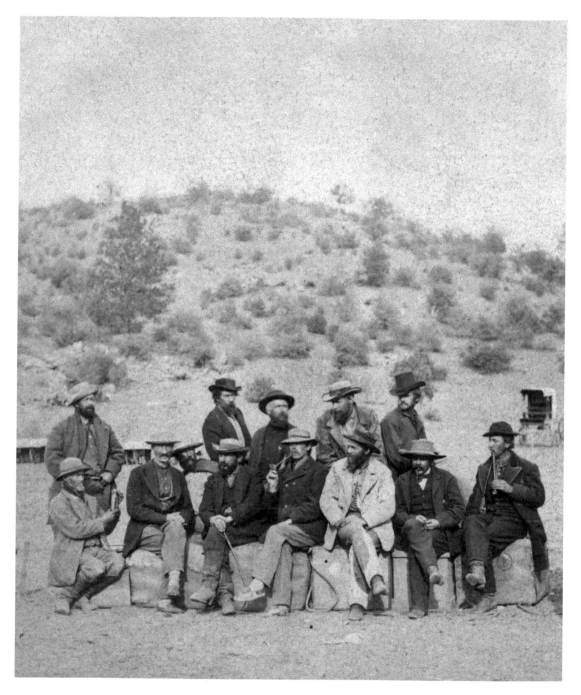

An 1871 surveying party in Prescott is frozen in time by photographer Timothy O'Sullivan.

In 1858 Camp Colorado, later
to be known as Camp Mojave,
and later still as Fort Mojave, was
founded by the United States
Army to keep watch over Beale's
Road while miners and settlers
crossed the Colorado River on
their way to California. Here an
exploration party from the Army
Corps of Engineers leaves Camp
Mojave and crosses the river in
1871.

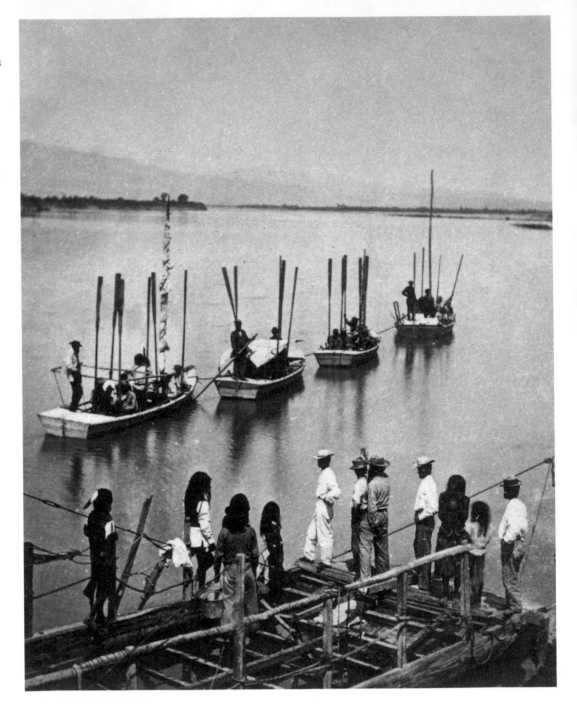

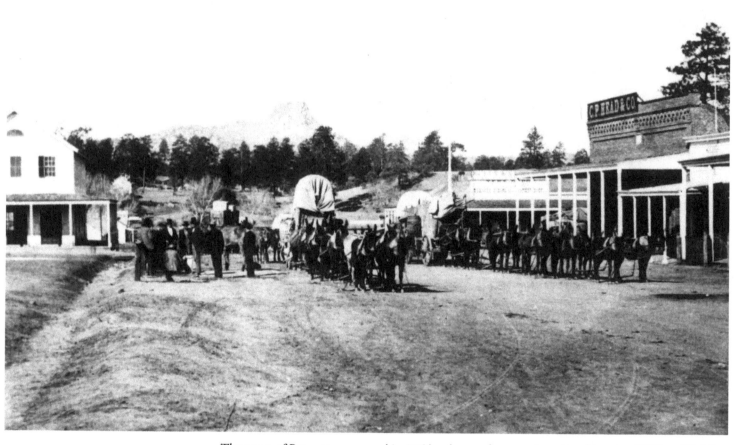

The town of Prescott was named in 1864 to honor the great American historian William Hickling Prescott. Prescott's book *History of the Conquest of Mexico* had been hugely popular with American readers since the 1846-48 Mexican War. This photo of Prescott shows local wagons traveling west past several Gurley Street saloons.

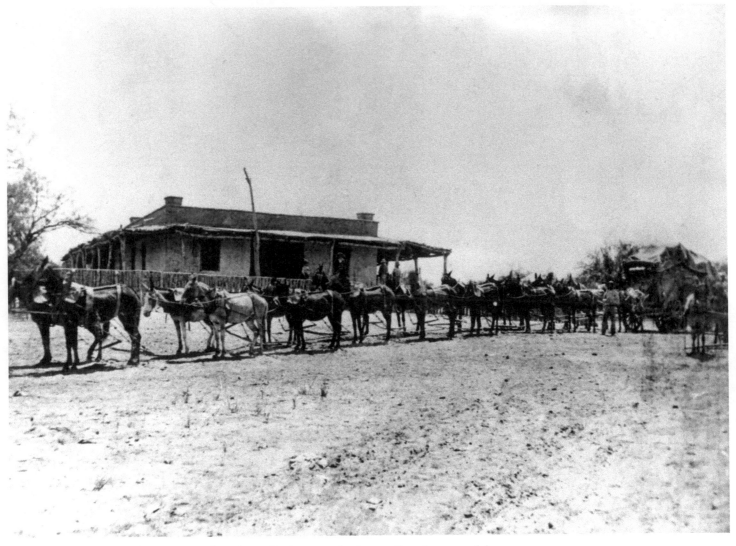

Freight wagons were used to move goods and supplies between the few small settlements of the Arizona Territory. Loading their supplies at Fort Yuma, these freighters could successfully cross the many desolate miles of the Sonoran Desert. Here a territorial freighter passes in front of the freight and mail station at Gila Ranch in about 1878. By 1880 the settlement would move to be near the railroad and would be renamed Gila Bend.

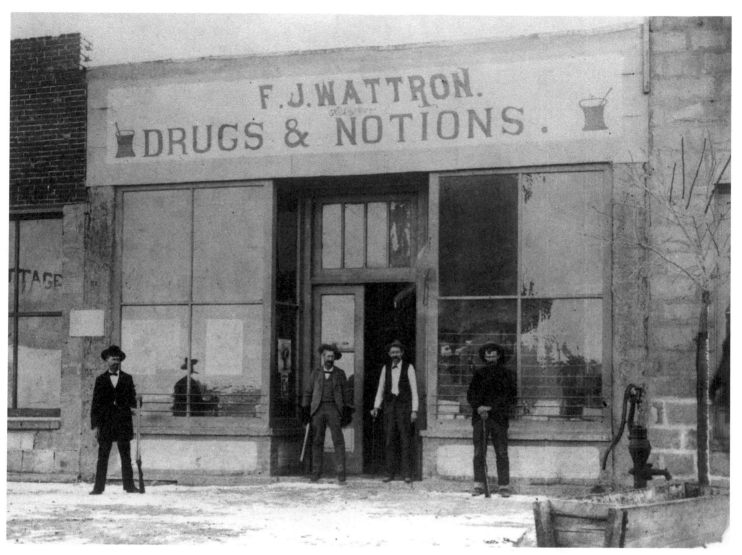

Holbrook sheriff (and perhaps druggist) Frank Wattron watches over his town while standing in front of F. J. Wattron Drugs & Notions around 1880. Holbrook in the 1880s was the headquarters of the Aztec Land and Cattle Company and its infamous "Hashknife" cowboys, described as the "thievinist, fightinest bunch of cowboys" in the West. The company once kept 33,000 head of cattle on a range that extended from just east of Flagstaff to the Arizona–New Mexico border.

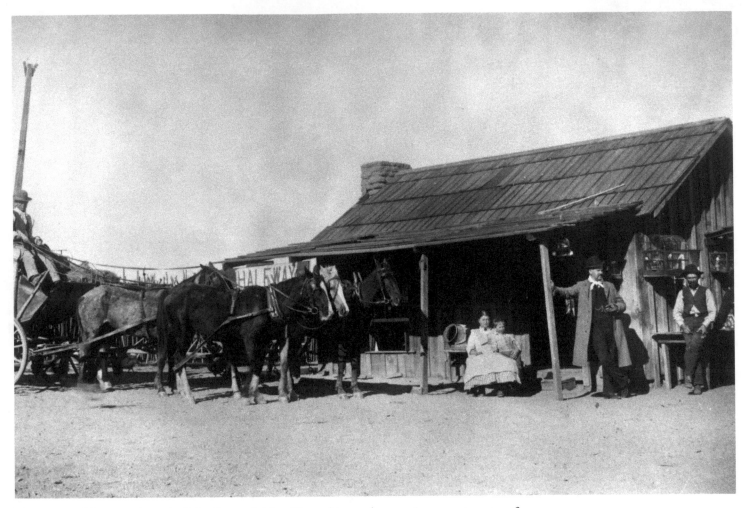

The Concord Stagecoach was built in Concord, New Hampshire, and was an important means of transportation for Arizona Territory citizens in the 1880s. Each 2,500-pound coach was 8 ½ feet long, 8 ½ feet tall, and 5 feet wide. If someone agreed to ride on the roof, the Concord could carry 12 passengers. Stage stations like this one in Pima County were built 20 miles apart so that horses and passengers could rest and refresh.

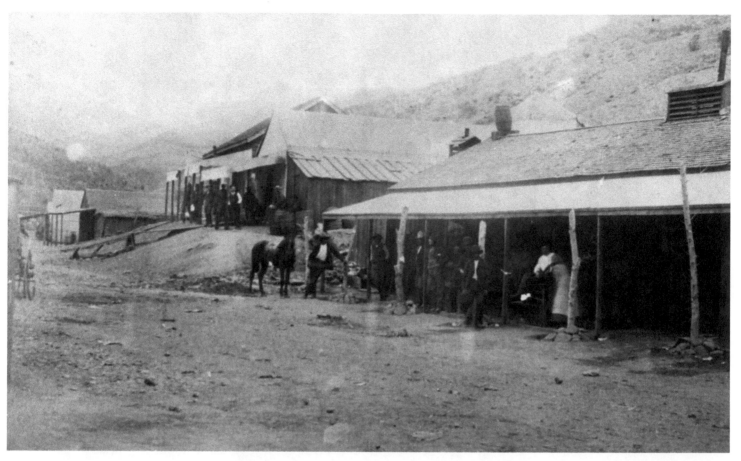

Clifton is a copper mining town in the far southeast corner of Arizona. The town is located along the San Francisco River, with high, mountain cliffs rising from the canyon floor. The name Clifton probably originated as a shortening of "cliff town." A U.S. post office opened at Clifton in 1875. This photo shows a few stores along the town's main street in 1884.

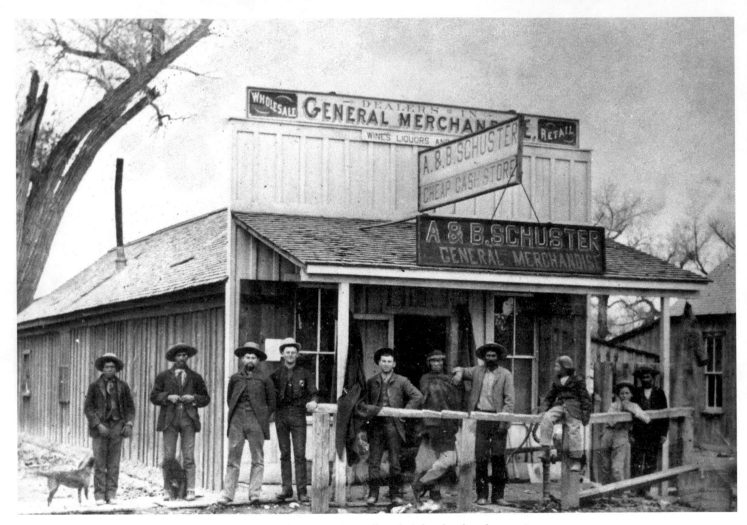

The town of Holbrook received its name in 1882 to honor H. R. Holbrook, a local railroad executive. It was a rough-and-tumble cowboy town said to be "too tough for women and churches!" All the vices typical of a territorial town were found there in places such as a saloon named the Bucket of Blood. This photo shows the A. & B. Schuster General Store, located just down the street from the famous Bucket of Blood.

In 1866 settlers in the Verde River Valley created their own private fort at the junction of the Verde River and Clear Creek and named it Camp Lincoln. Army regulars soon occupied the fort, and in 1868 they renamed it Camp Verde. Disease was common near the river, so the camp was moved a mile south in 1871, and in 1879 it was renamed Fort Verde. This photograph shows soldiers and civilians at Fort Verde in 1886.

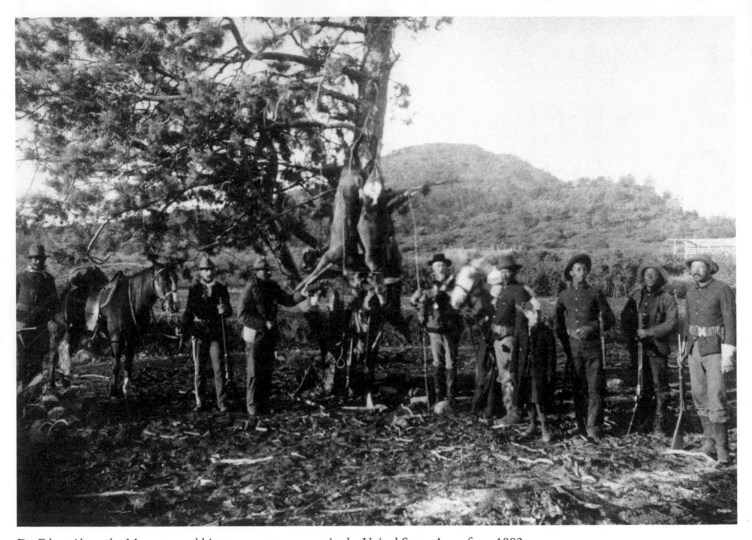

Dr. Edgar Alexander Mearns served his country as a surgeon in the United States Army from 1882 to 1889. Assigned to Fort Verde in 1883, he was also an avid ornithologist, field naturalist, and photographer. In 1887 he photographed this group of Fort Verde soldiers showing off their hunting skills along Oak Creek in central Arizona.

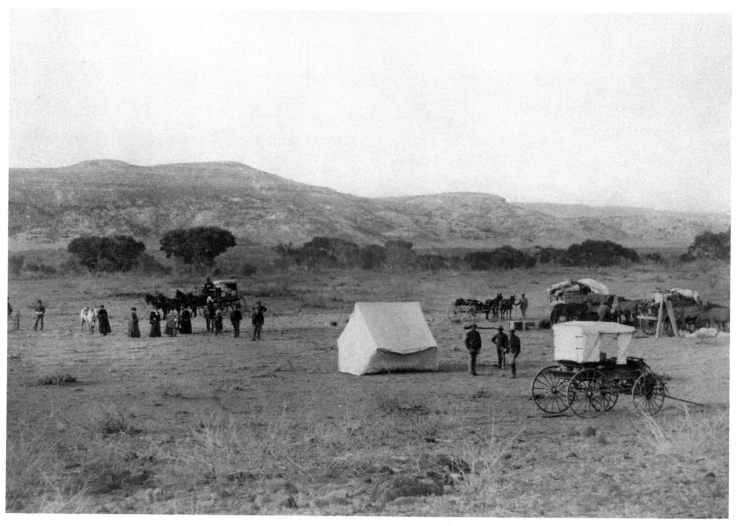

This 1887 photograph taken by Dr. Edgar Mearns shows an overnight bivouac at Clear Creek for a detachment of Fort Verde soldiers traveling the 150 miles to Fort Thomas, which was located in the Gila River Valley in southern Arizona. The commanding officer was Major C. B. McLellan, whose tent is shown here at center.

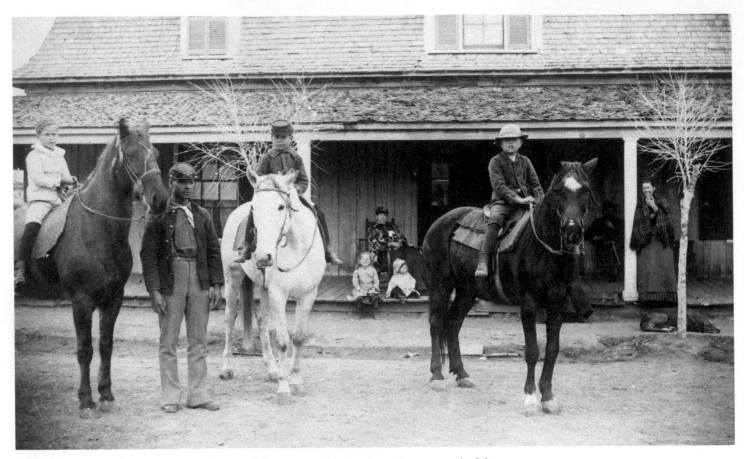

Fort Verde became the headquarters of General George Crook when he took command of the Department of Arizona in 1871 and began a military campaign known as the Indian Wars. Like all nineteenth-century army posts in Arizona, Fort Verde was never enclosed by walls or stockades. In addition, Fort Verde never came under attack by hostiles. In 1887 Dr. Edgar Mearns photographed these three officers' children under the watchful eye of a Buffalo Soldier—the name given by the Indians to the African American troops who served out west after the Civil War.

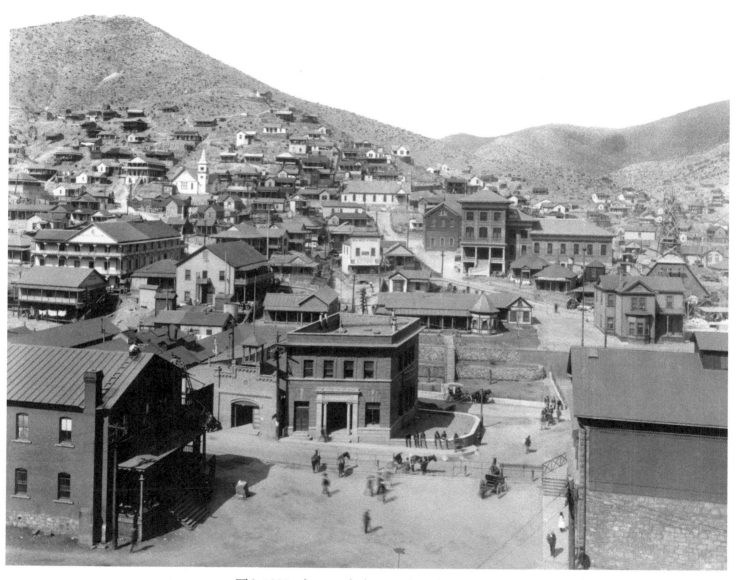

This 1890s photograph shows Bisbee, the "Queen of Arizona's Copper Camps." In 1877, while tracking Apache Indians in the Mule Mountains, army scout John Dunn came upon an outcropping of ore. Because of his army duties, he could not work the claim, so he grubstaked local miner George Warren to work the ore. They named their mine at Bisbee the Copper Queen, and by the early 1900s it was the most productive copper mine in Arizona.

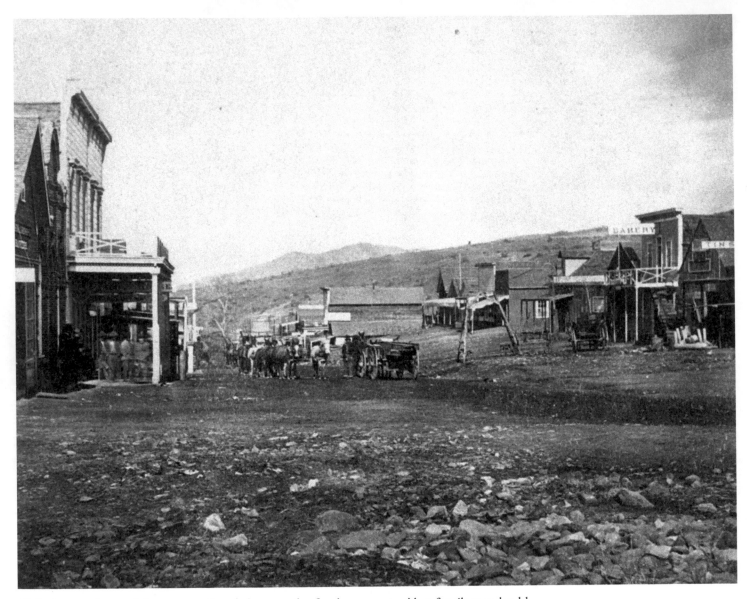

Globe is one of many Arizona towns founded as a result of early prospectors' lust for silver and gold. Legend tells that in the early 1870s two men came upon a boulder of silver so large they announced to the world it "was as big as the globe." By the time of this 1890s view of the town's principal street, Broad Street, copper ore had become king of Globe.

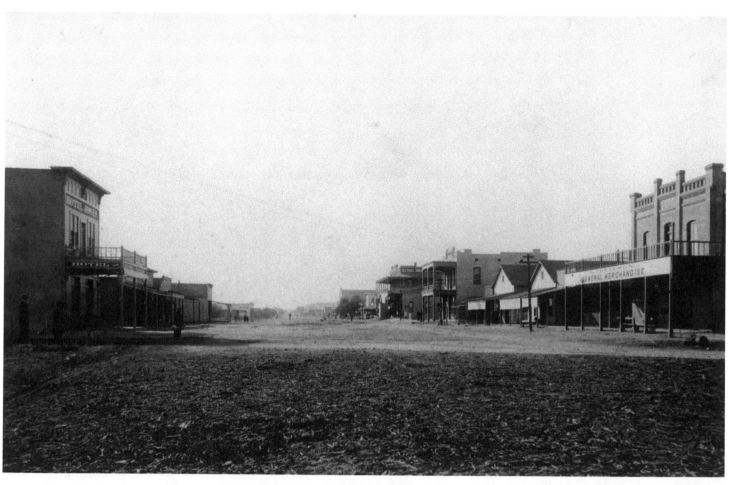

This 1890s view of Main Street in Yuma shows the Hotel Jones and the Lewinson General Merchandise store. Luckily it seldom rained in Yuma—when it did, this 1890s dirt street turned into a quagmire of mud and manure.

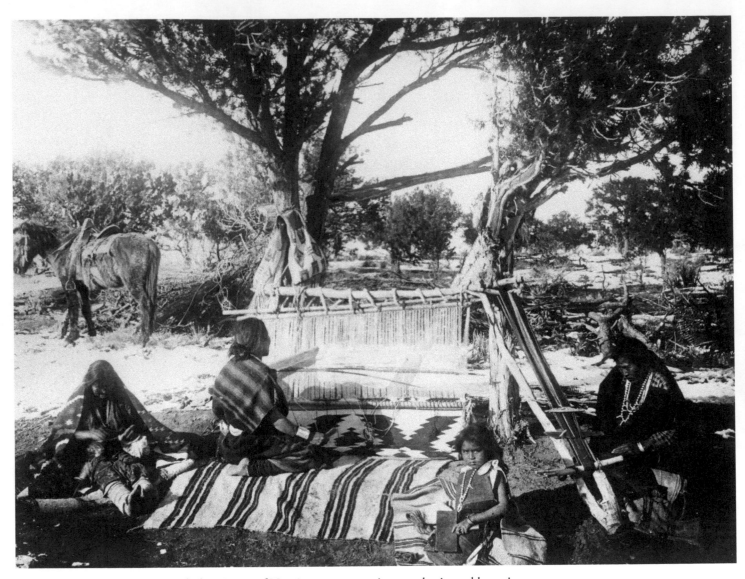

Photographer James Mooney took this picture of Navajo women weaving on a horizontal loom in a camp at Keams Canyon in northeastern Arizona, about 1893. The Navajo, known even then for their beautiful woven wool rugs, were just one of many American Indian tribes that Mooney photographed. He was a self-taught ethnologist who worked for the Smithsonian's Bureau of American Ethnology from 1885 until his death in 1921.

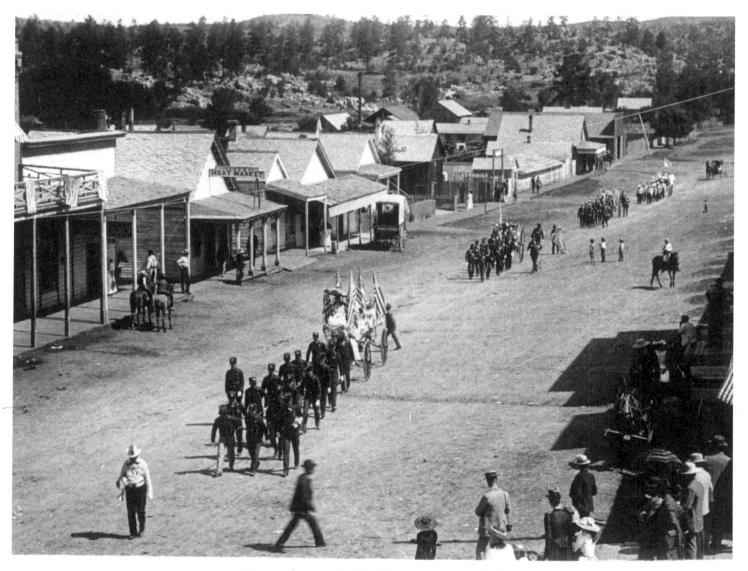

Prescott photographer E. M. Jennings captured this image of a company of Prescott fire fighters marching down Montezuma Street on Independence Day of 1891. Just three years earlier, on July 4, 1888, the birth of professional rodeo in America took place during this annual Prescott celebration. Today, the Prescott Frontier Days Rodeo claims to be the "World's Oldest Rodeo."

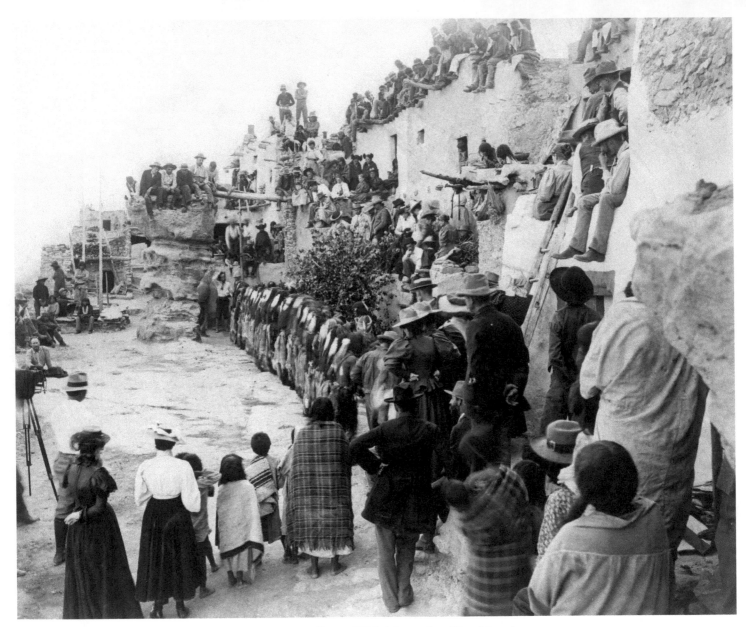

Ben Wittick photographed this snake dance at the Hopi village of Walpi, located on First Mesa, in 1897. Wittick brought his camera to the Wild West in 1878 as an employee of the Atlantic and Pacific Railroad. He traveled tirelessly throughout the Southwest, photographing the land, the railroad, and the American Indian people. Wittick died in 1903 after being bitten by a rattlesnake.

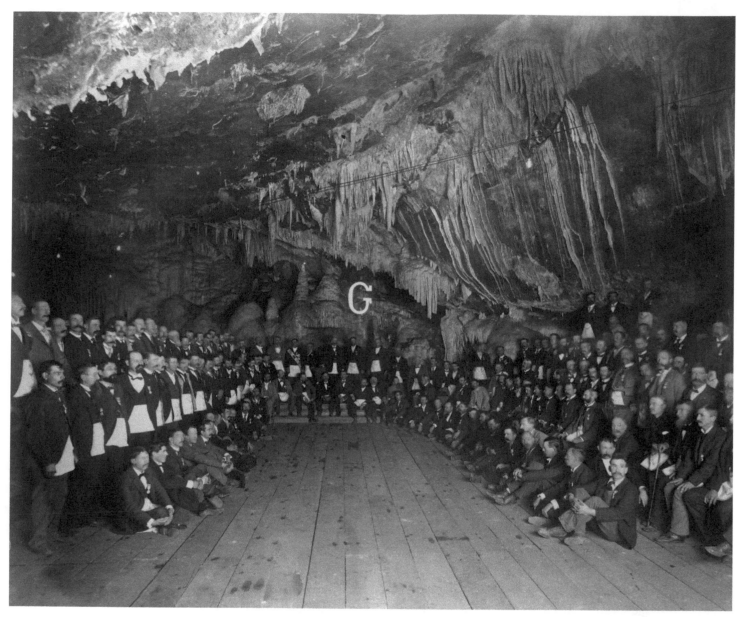

Freemasons played important roles in the settlement and development of most Arizona frontier towns. Here the men of the Grand Lodge of Arizona meet in a cave of the Copper Queen Mine of Bisbee on November 12, 1897. A wooden plank floor has been laid inside the cave, and the Masonic symbol G appears to be suspended from the cave's ceiling.

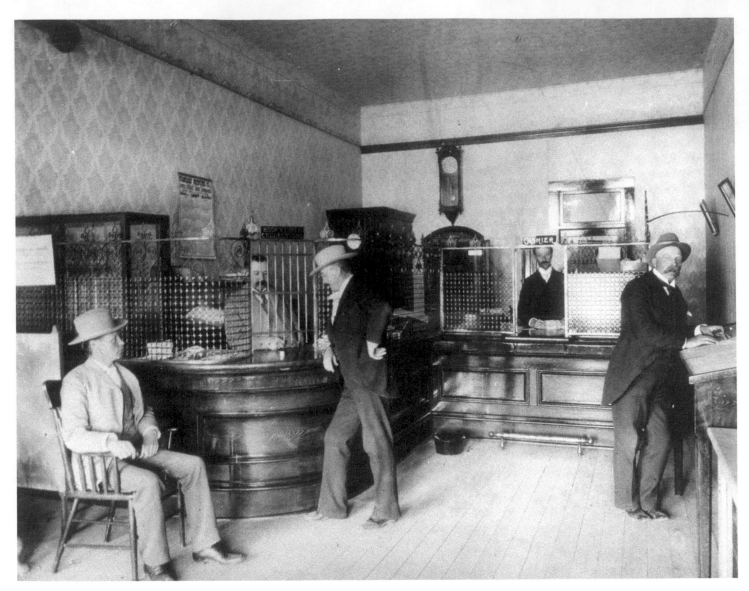

William "Buckey" O'Neill (center) and two friends pose inside the Prescott Bank of Arizona in 1897. O'Neill was a larger-than-life politician, lawman, miner, and writer. When the Spanish-American War began, he became the first man from Prescott to volunteer as one of Teddy Roosevelt's Rough Riders. O'Neill was killed at the Battle of Kettle Hill, Cuba, on July 1, 1898.

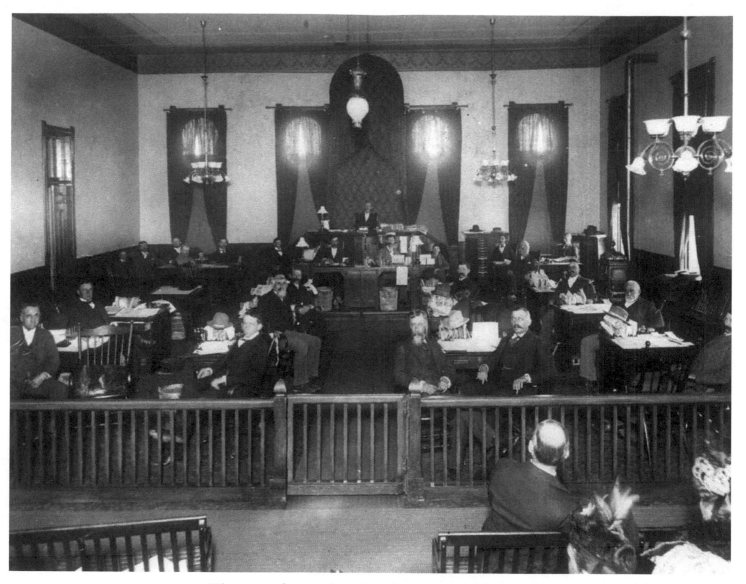

When most of present-day Arizona became a part of the United States in 1848, it did so as a segment of the Territory of New Mexico. It wasn't until February 24, 1863, that President Abraham Lincoln signed the bill creating the Territory of Arizona. This photograph shows Arizona's 19th territorial legislature in session in Phoenix in 1897.

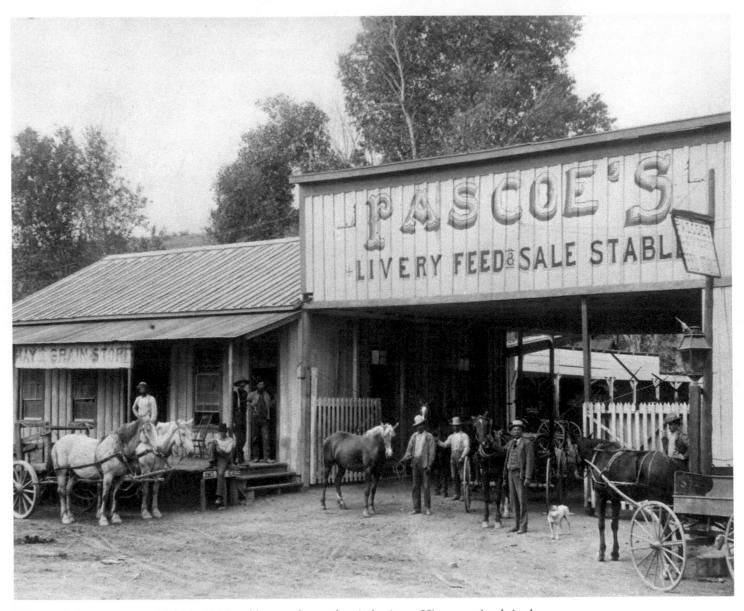

Thomas A. Pascoe came to Globe in 1886 and began a hay and grain business. His enterprise thrived, as suggested by this 1898 photo, but he sold the store in 1899 to his brother. With two other men from Globe, Thomas also developed the town's first water reservoir, which held 140,000 gallons of spring-feed water.

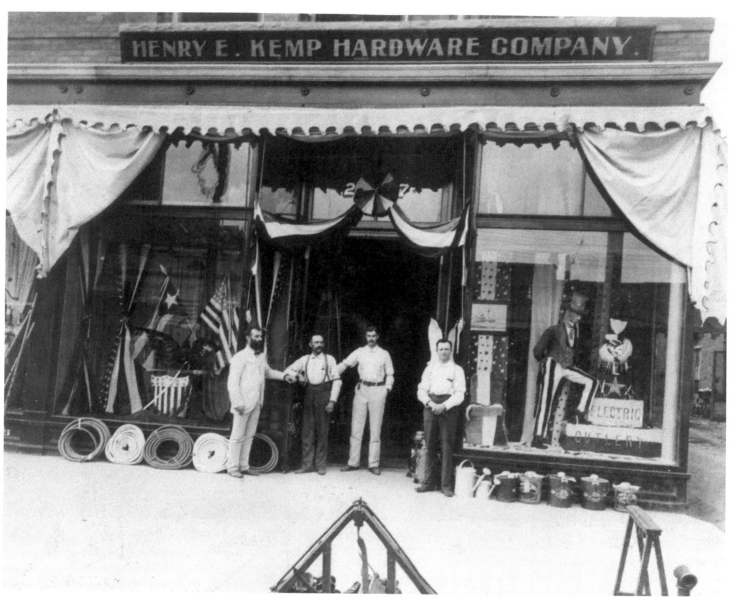

In 1899 Phoenix was a rapidly growing farming community on the banks of the Salt River, a new territorial capitol was being constructed 12 blocks west of downtown, and the Henry E. Kemp Hardware Company was stocked with the latest merchandise. The Kemp store awning would be opened to help provide welcome shade during the hot Arizona summers.

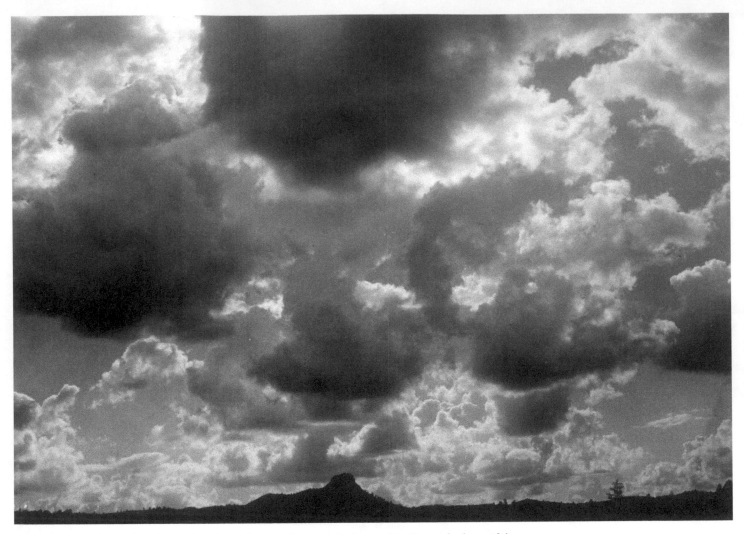

Arizona's rugged, varied landscape has always been a photographer's paradise. From the beautiful Sonoran Desert of the south, to the large ponderosa pine forest of the Mogollon Rim, to the stark beauty of the Colorado Plateau, Arizona has all manner of views to attract the camera's lens. This turn-of-the-century photo shows a cloudy sky above Thumb Butte, just west of downtown Prescott.

STATEHOOD AND CHANGE

(1900–1919)

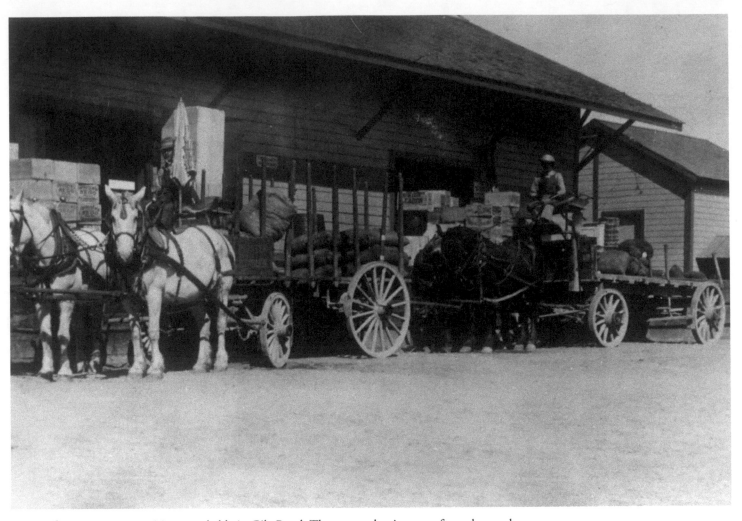

A pair of wagons carry provisions, probably in Gila Bend. The town takes its name from the nearly 90-degree turn the Gila River makes near the town site. When the railroad came through this desert region in 1880, the nearby water supply proved ideal for use by the steam locomotives. The water served other purposes, too—the boxes lining the wall at left in this image appear to contain Sego evaporated milk.

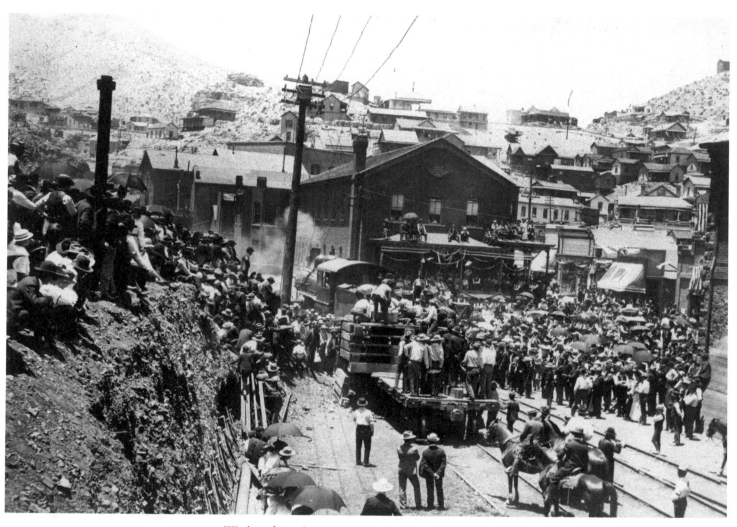

Workers from the Copper Queen mine at Bisbee gather to view a newly arriving ore shovel. Large steam-powered shovels like this one quickly changed how ore was dug from the Arizona copper mines.

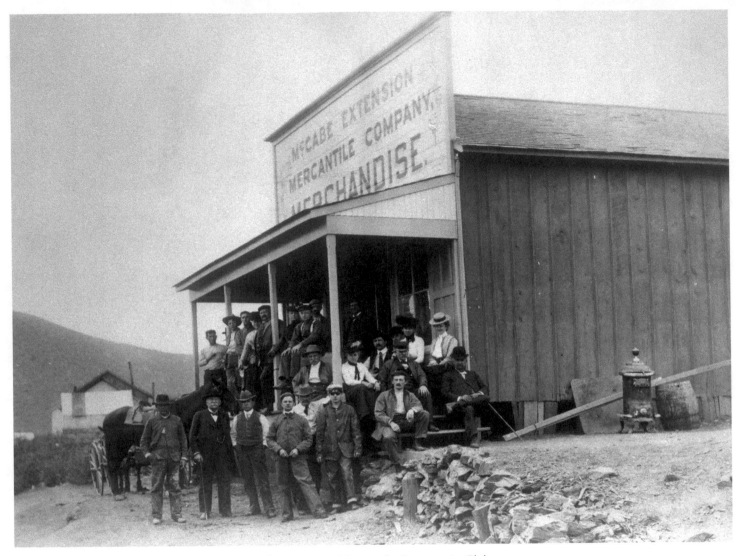

Company stores like the one owned by the McCabe Extension Mercantile Company in Globe provided mining families a place to buy fresh food and supplies, but the monopoly on goods and services held by such stores in the mining camps of Arizona did not always benefit the hardworking, low-paid miners.

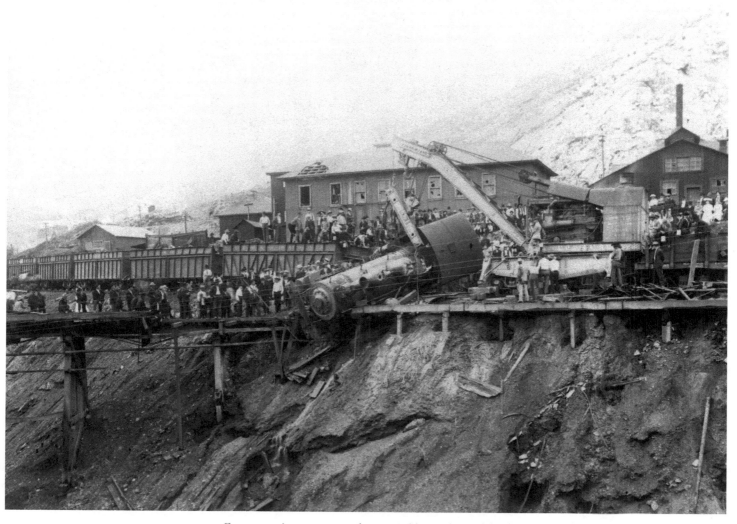

From cave-ins to catastrophes caused by pockets of deadly gas, mining accidents have always been an everyday danger in the lives of Arizona miners. Here an ore train has fallen from the tracks of the Copper Queen mine in Bisbee.

On May 7, 1900, President William McKinley arrived at Congress, Arizona, to visit the Congress Gold Mine, though he declined an invitation to ride to the bottom of the 3,000-foot mine shaft. McKinley was presented with a small gold bar, and each lady of the presidential party was given a gold nugget. Here a daughter of a local miner takes the opportunity to photograph the president.

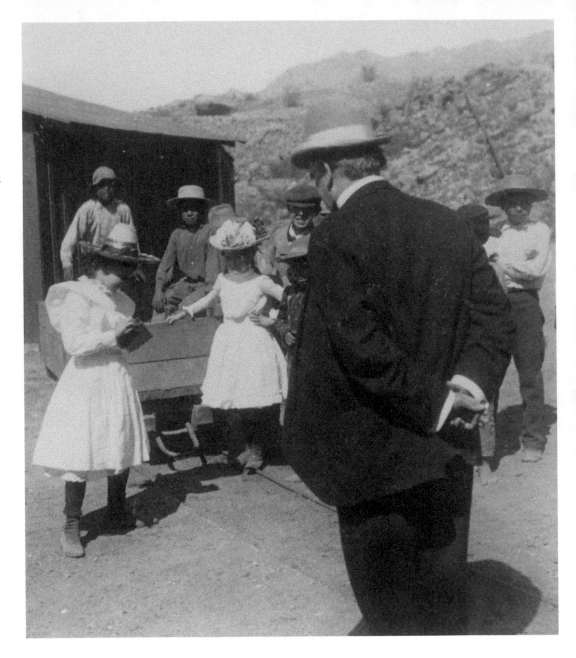

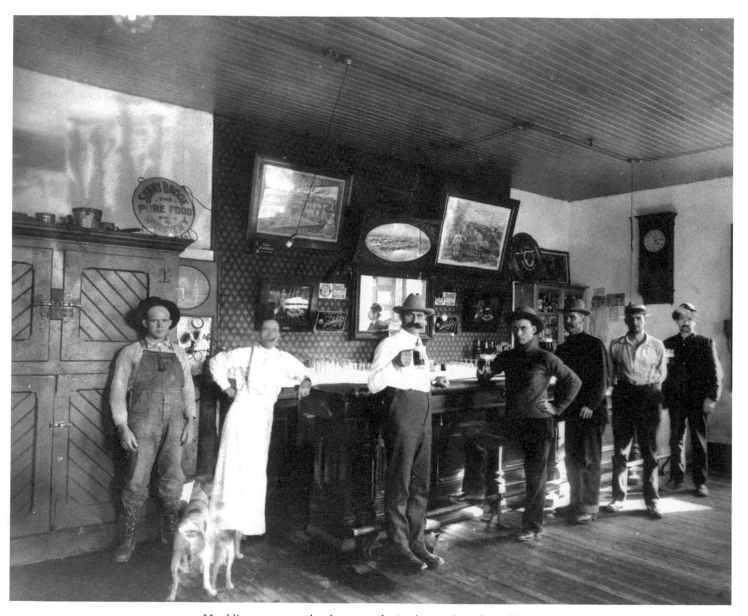

Hard liquor was not hard to come by in the rough-and-tumble Arizona mining towns. With the mines operating three shifts, seven days a week, the saloons stayed open around the clock. These men are at the bar of the Van Slyck & Meyers Whiskey Company in Globe, around 1902.

A steam locomotive passes over the railroad bridge built by the Atlantic and Pacific Railroad at Canyon Diablo in northern Arizona. Completed in 1890, the bridge successfully spanned a 255-foot-deep chasm. Elements of the bridge were precut and assembled elsewhere, but a mistake in measurement resulted in the bridge coming up short by three feet. Correcting the error delayed the bridge opening by seven months.

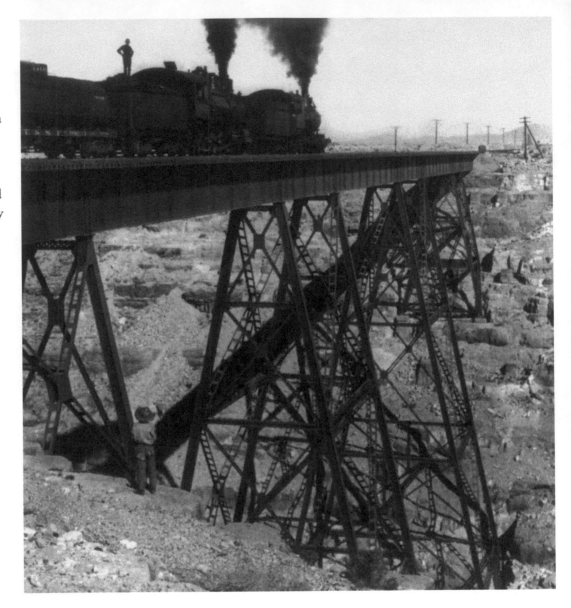

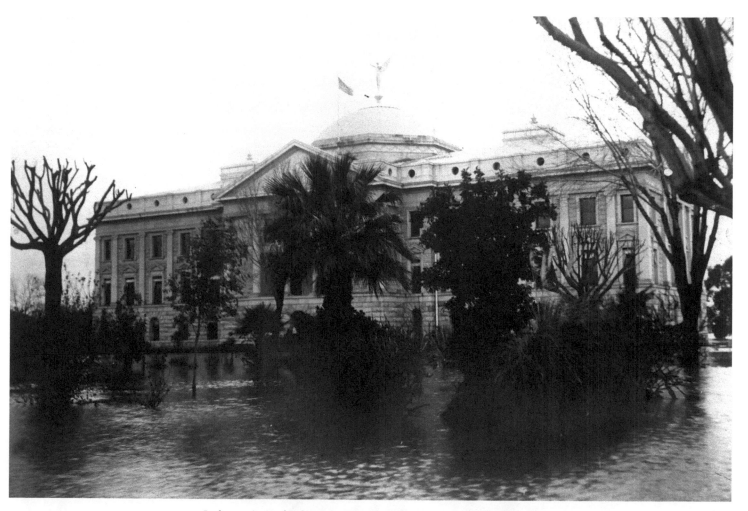

It does rain in the Sonoran Desert, and when the rains are heavy, the desert rivers can quickly overflow and flood surrounding areas, as this 1905 image of the Arizona Territorial Capitol in Phoenix shows. Cycles of drought followed by flooding motivated Phoenix residents to form the Salt River Valley Water Users' Association and to build Roosevelt Dam. The dam stored water for times of drought and captured the heavy rains to prevent flooding.

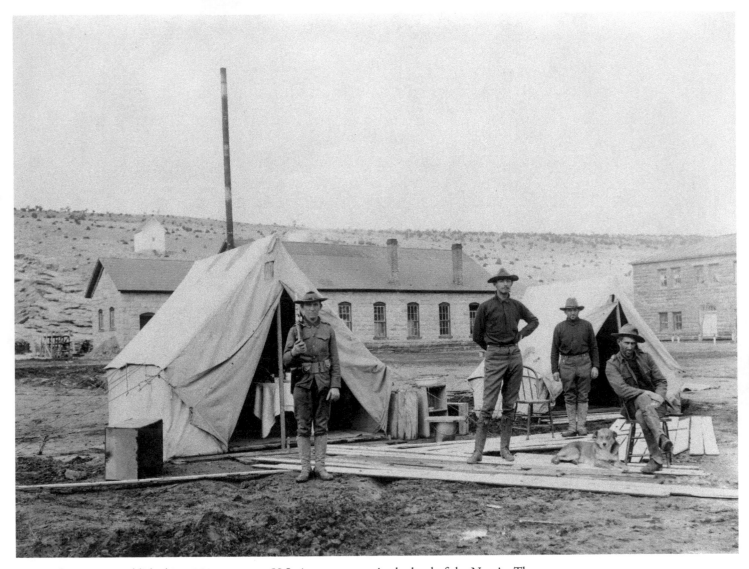

Fort Defiance was established in 1851 to create a U.S. Army presence in the land of the Navajo. The fort lived up to its name, for many horrific battles were fought between the soldiers and the native people. It was from Fort Defiance in 1864 that the forced removal known as the Navajo Long Walk began. In 1868 Fort Defiance was reestablished as an Indian agency, and in 1905 the military was still present, as shown by this photo of the officers' quarters.

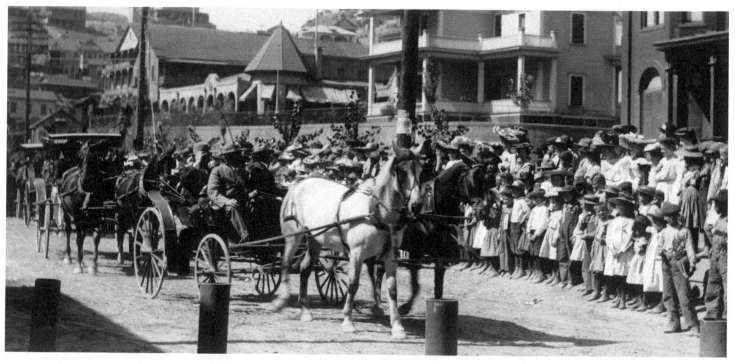

Bisbee in 1905 boasted a population of more than 20,000 residents. The mining town's notorious Brewery Gulch, known for its 47 saloons and its "soiled doves," was called the "liveliest spot between El Paso and San Francisco." But Bisbee was also home to Arizona's first community library and first golf course, as well as the state's oldest ballfields. Here a few of those 1905 Bisbee folks enjoy an old-fashioned community parade.

Edward S. Curtis was one of the great photographers of the American West. His 30-year North American Indian Project attempted to capture and preserve images of American Indian people living as they had before contact with the culture. His life's work cost him his marriage and his health, but he left a photographic masterpiece. These four Hopi women of the village of Walpi were photographed by Curtis in 1906.

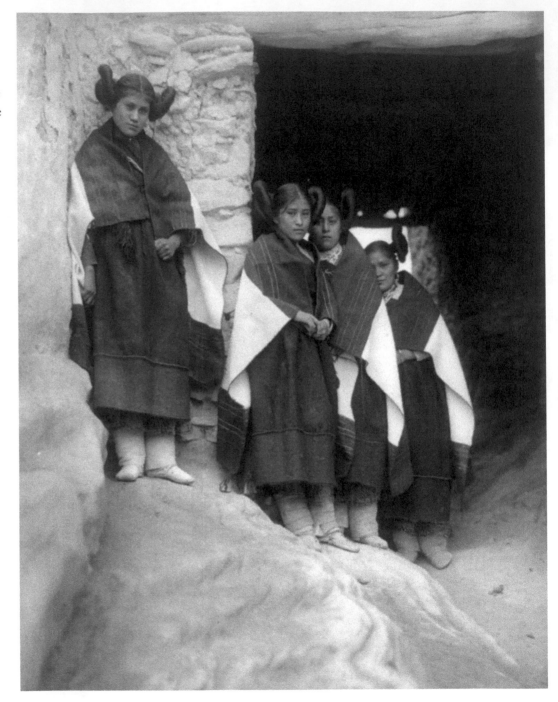

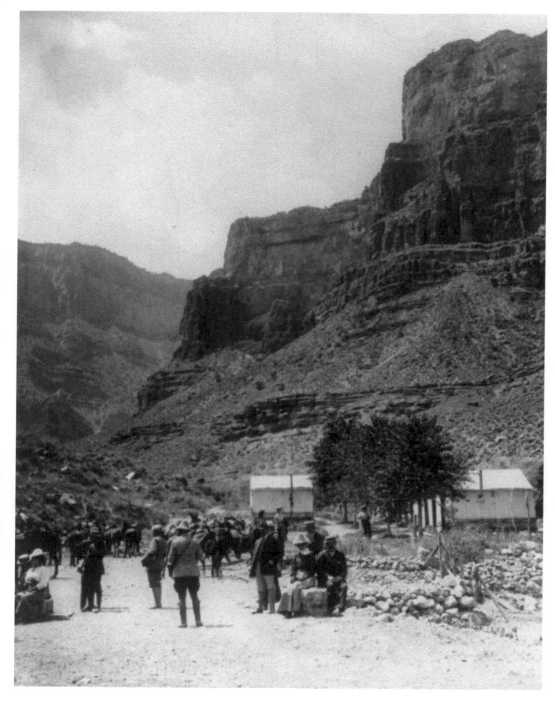

In 1902, while working for the U.S. Geological Survey, F. E. Matthes began to map the Grand Canyon. By 1905 he had created the first topographic maps of the Vishnu, Bright Angel, and Shinumo quadrangles. Perhaps benefiting from Matthes' work, these tourists in 1907 have descended to a canyon campsite 3,100 feet below the south rim.

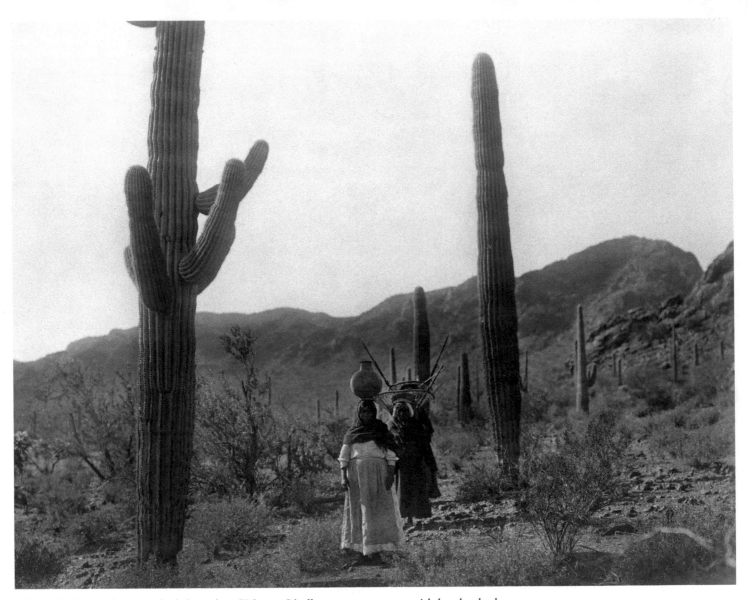

Edward S. Curtis photographed these three Tohono O'odham women—two with burden baskets called "kiho carriers," the third with a ceramic jug—in the Sonoran Desert of southern Arizona in 1907. The tribal name Tohono O'odham translates as "people of the desert." The conquistadors called them Papago, which translates as "tepary-bean eater." The traditional Tohono O'odham homeland extends from southern Arizona into northern Mexico.

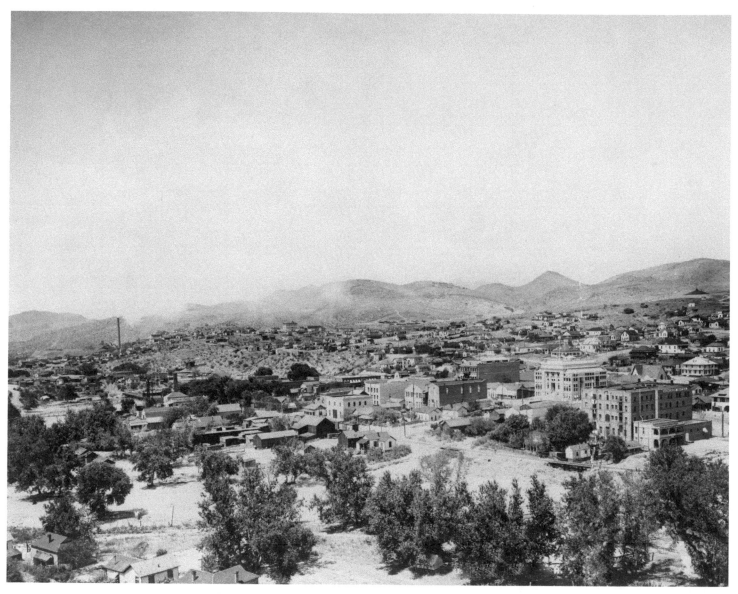

This is how downtown Globe appeared in 1909 when a visitor calling himself William T. Phillips came to the Arizona mining town accompanied by a new bride, Gertrude Livesay. Many historians believe Phillips was really Richard LeRoy Parker—better known as Butch Cassidy, who was thought to have died in Bolivia in 1908. In 1910 William Phillips left Globe for Spokane, Washington, where he died in 1937, leaving questions about his true identity to be debated to this day.

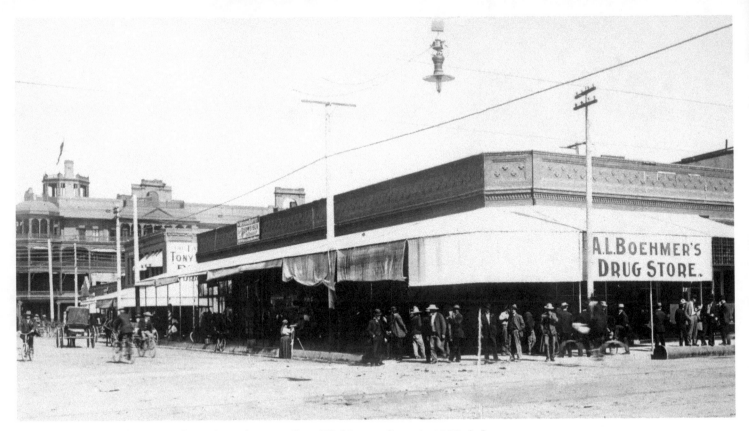

This Phoenix view is facing north on Central Avenue from Washington Street in 1908. A. L. Boehmer's Drug Store stands on the northeast corner, and the famous Adams Hotel is seen in the background.

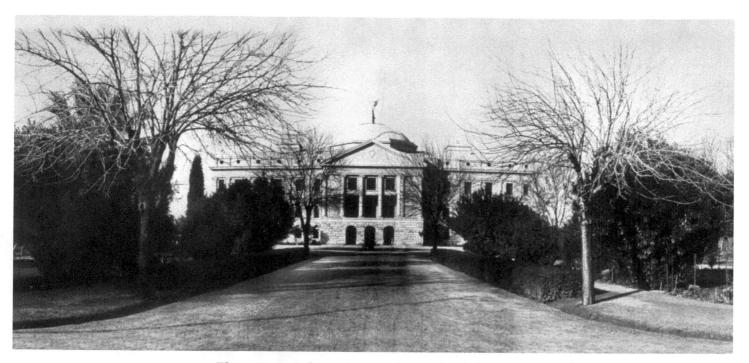

This 1908 view of the Arizona Capitol in Phoenix faces west from Washington Street. Completed in 1901, the Ionic Grecian–style stone building measures 184 feet long and 76 feet high. All of the stone was quarried from Arizona mountains. The Capitol dome features a 7-foot, 600-pound weather-vane statue called *Winged Victory.*

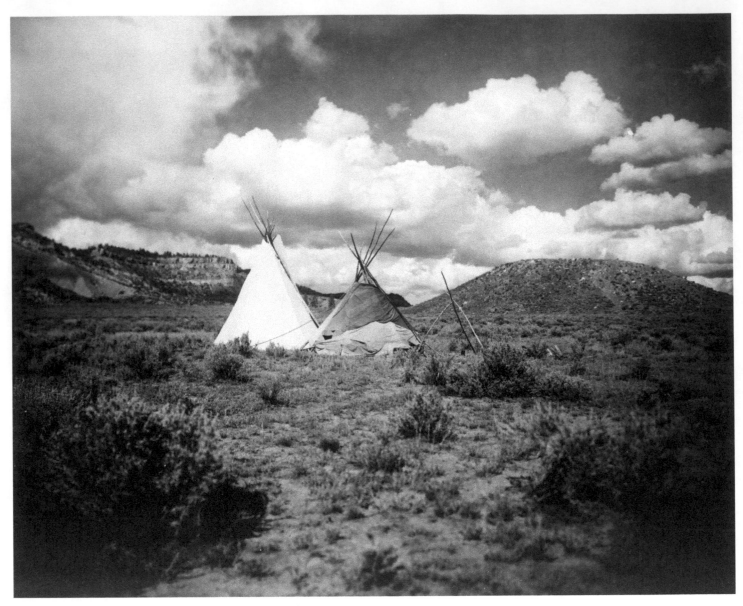

Although this photograph made in 1909 by the Fred Harvey Company is titled "Two Apache Indian teepees in a hilly landscape of Arizona," the Apache people of Arizona traditionally did not use the tepee. The tepee and other nontraditional Apache items began to show up in Arizona when the Fred Harvey Company began bringing tourists who wanted to have their pictures taken in the "Wild West."

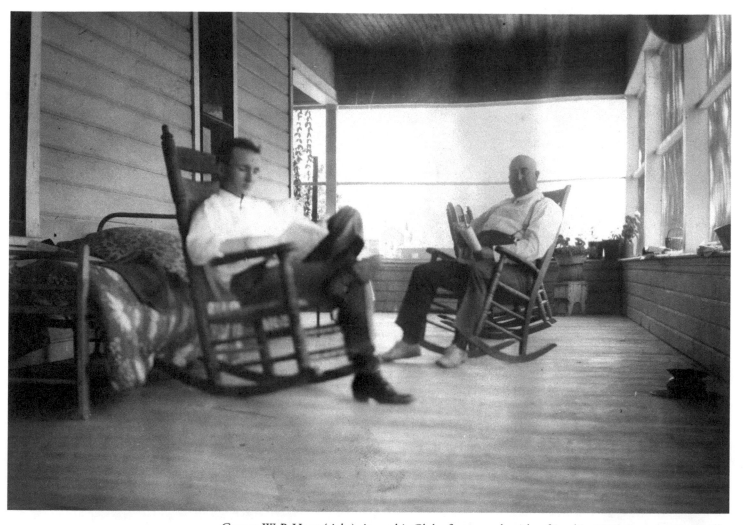

George W. P. Hunt (right) sits on his Globe front porch with a friend in 1909. Born in Huntsville, Missouri, in 1859, Hunt came to Globe as a young man in 1881. Between 1893 and 1910 he became probably the best known and respected politician in the Arizona Territory. He was elected Arizona's first state governor in the election of 1911.

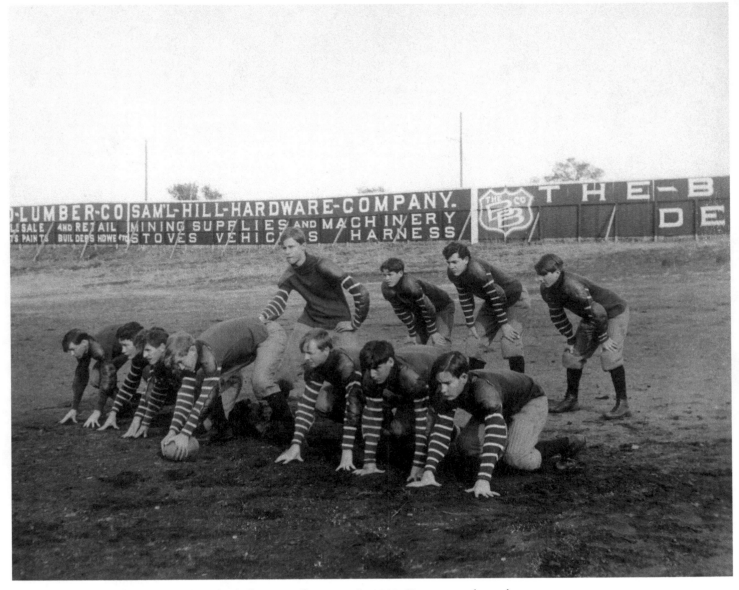

The first Prescott High School Badgers football team strikes a pose in 1910. Sixteen years later, the 1926 Badgers would become the only undefeated football team in the school's history, with an 8-0 record. That year the young boys from Prescott won the Northern Arizona championship, prevailing in a league that included, besides Prescott, teams from Flagstaff, Clarkdale, Williams, Winslow, Jerome, and Kingman. Prescott outscored its opponents by a combined 147-13.

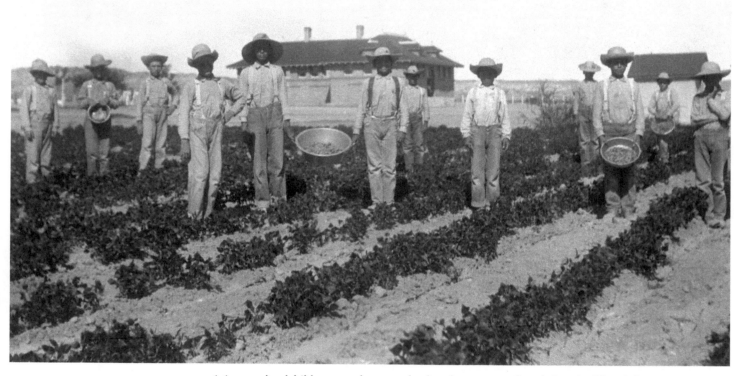

Arizona schoolchildren were long taught that the state was founded on its "five Cs"—copper, cotton, cattle, citrus, and climate. The five Cs provided the economic foundation upon which Arizona grew from a Wild West territory into the 48th state of the Union. This photo from around 1912 shows students working in the cotton fields at the Arizona Industrial School for Wayward Boys and Girls, located at Fort Grant.

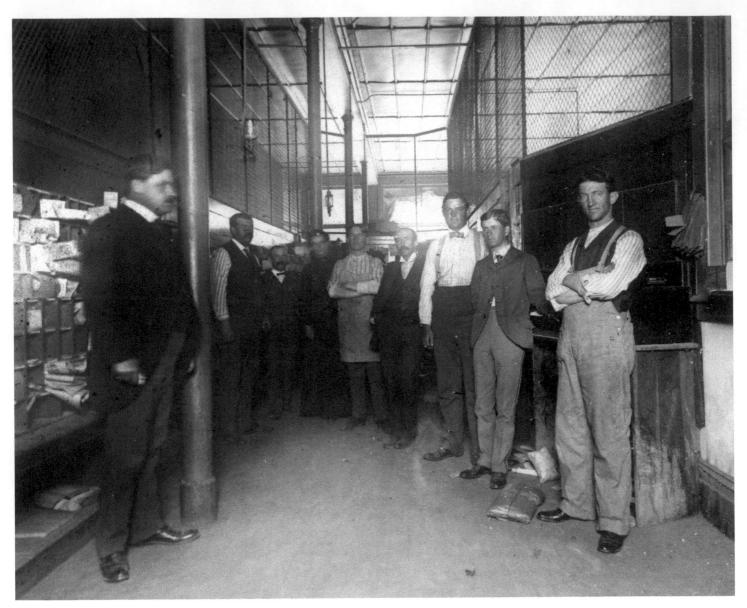

The first post office in Phoenix was established on June 15, 1869, with Jack Swilling as the postmaster. Most historians credit Swilling with founding Phoenix in 1867 when he started the Swilling Irrigation and Ditch Company to reopen the ancient Hohokam irrigation canals and once again bring water to desert fields. Here a later postmaster, James McClintock, and staff stand proudly inside a new Phoenix post office around 1910.

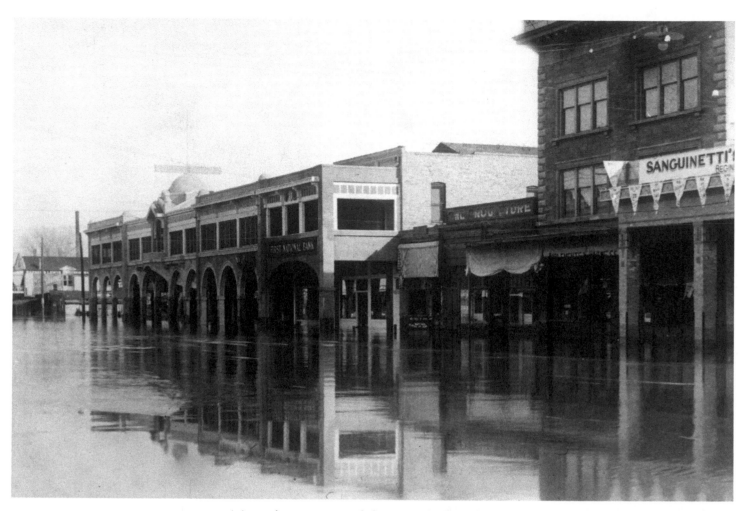

Arizona desert towns needed access to fresh drinking water, so they were always developed close to water sources. However, heavy desert thunderstorms could make creeks, streams, and rivers rage with floodwaters that would overwhelm levees and dams and rush into the towns. Here downtown Yuma has been flooded by the Colorado River—a source of drinking water one day, destroyer of the town the next.

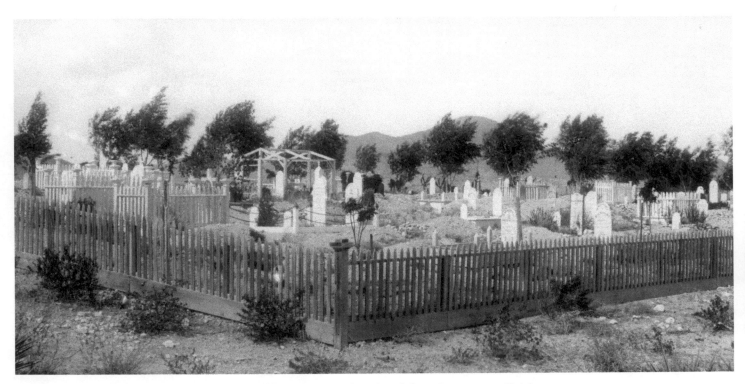

The Tombstone City Cemetery saw its first burial in 1882, even though it did not become an official cemetery until 1884, the year the notorious Boot Hill Cemetery closed. Shown here around 1910, the Tombstone City Cemetery is today in great need of restoration. To quote a local restoration activist: "These are the real people who stopped in this hellhole of a desert to make a life and a town."

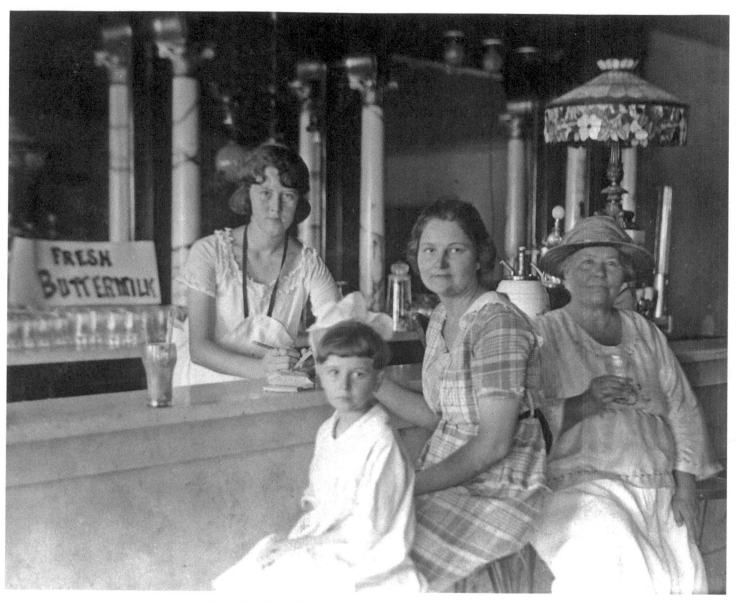

Casa Grande was founded in 1879 at the terminus of a railroad line from the copper mining district. In fact, the settlement was first called Terminus, but the name was later changed to Casa Grande in honor of a Hohokam Indian ruin located some 21 miles from the railroad site. By 1910 a local family could enjoy a cool soda at this Casa Grande fountain to help cope with the Sonoran Desert summers.

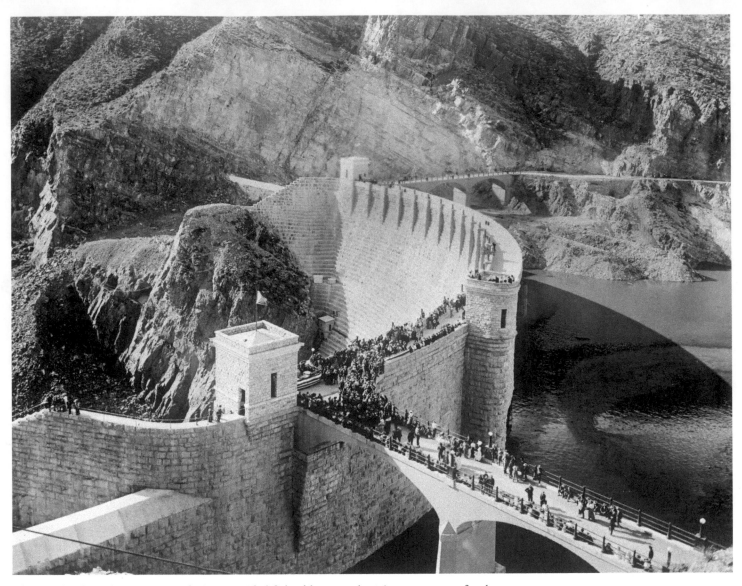

The Newlands Reclamation Act of 1902 provided federal loans to the 16 western states for the funding of irrigation projects. As a result, nearly every major river in the West was dammed. Built across the Salt River, some 40 miles east of Phoenix, Roosevelt Dam was the first Newlands Reclamation Act project in Arizona. The guest of honor at the March 18, 1911, dedication ceremony was Theodore Roosevelt, for whom the dam was named.

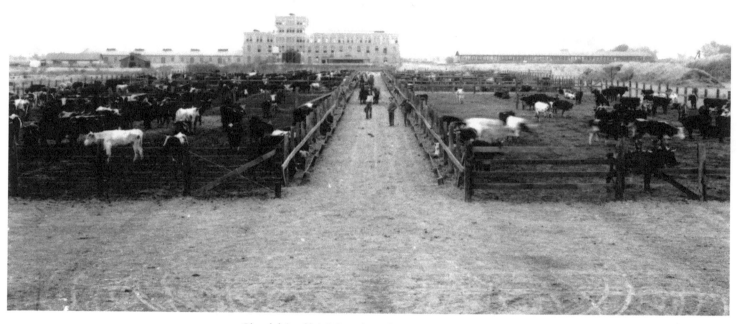

Glendale's official founding date is given as February 27, 1892, the day the New England Land Company surveyed the first residential area for the Church of the Brethren of Illinois. With completion of Roosevelt Dam two decades later, Glendale could count on a stable water supply and became an agricultural paradise, producing lettuce, melons, sugar beets, and cotton. Cattle ranching prospered as well, evident by the size of the Glendale stockyards seen here in 1913. A sugar beet factory looms in the distance.

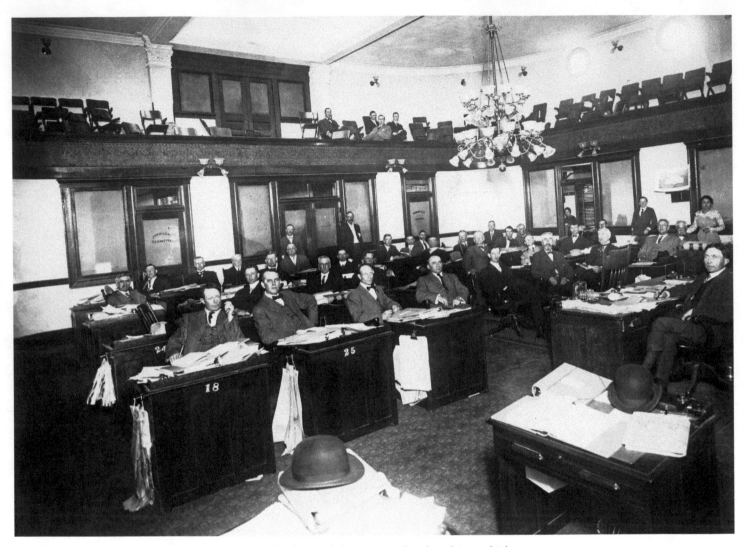

On February 14, 1912, President William Howard Taft signed the Arizona Statehood Act, which made Arizona the 48th state of the Union. In Phoenix, Governor George W. P. Hunt led Arizona citizens in a celebration down Washington Street to the State Capitol, where he gave his statehood address from the second-floor balcony. With statehood achieved, the first Arizona state legislature, shown here in 1913, began its work.

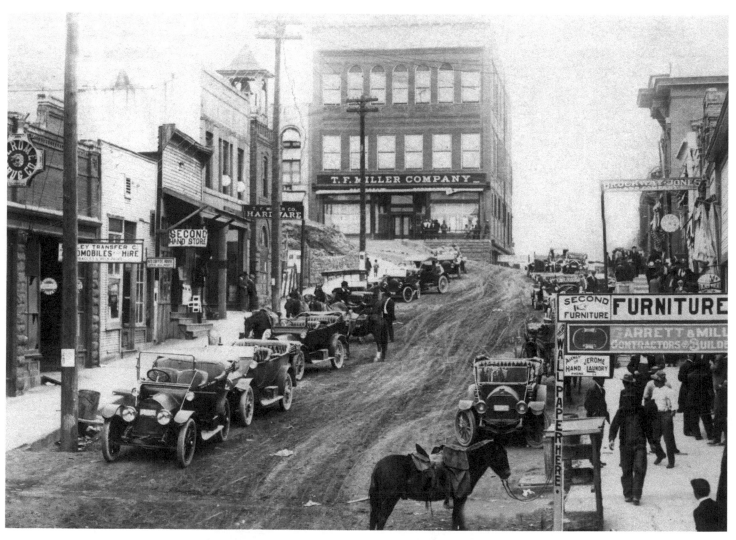

The copper mining town of Jerome was built on the side of Cleopatra Hill in 1883. It was named after New York investor Eugene Jerome, who never visited the town. Jerome's United Verde Mine produced more than $1 billion in silver, gold, and copper during its 70 years of operation. By 1915, when this photo was taken, the population of Jerome had grown to over 2,500 citizens.

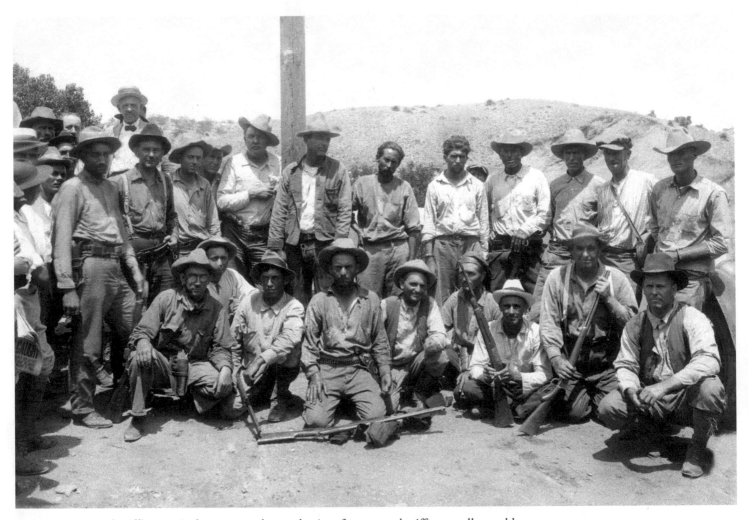

Posse comitatus or sheriff's posse is the common-law authority of a county sheriff to enroll any able-bodied male aged 18 or older to help keep order or pursue a felon. Lawmen of the West often turned to fellow citizens for help under the terms of that authority. This photograph taken around 1915 in Nogales, Arizona, appears to be of a Santa Cruz County sheriff's posse with two prisoners.

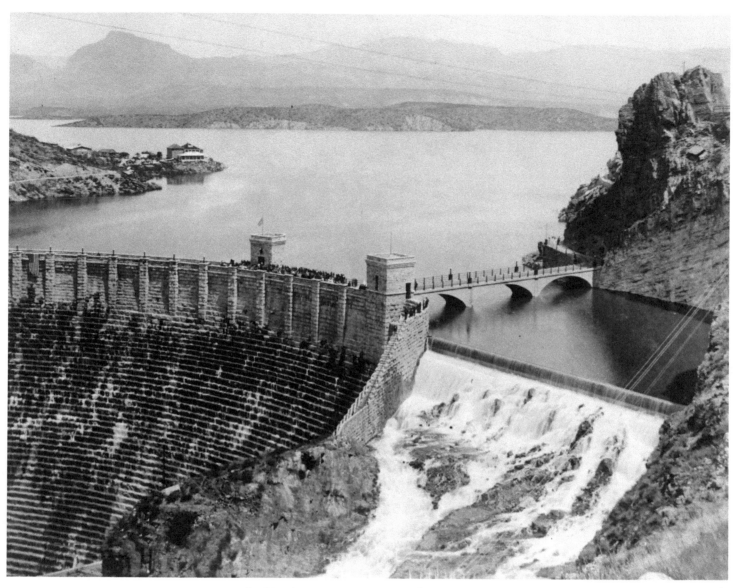

In this winter 1915 image, water from Roosevelt Lake rushes through the overflow spillway of Roosevelt Dam. This marked the first time since the dam's completion in 1911 that the reservoir reached its full capacity, requiring that excess water be released into the Salt River.

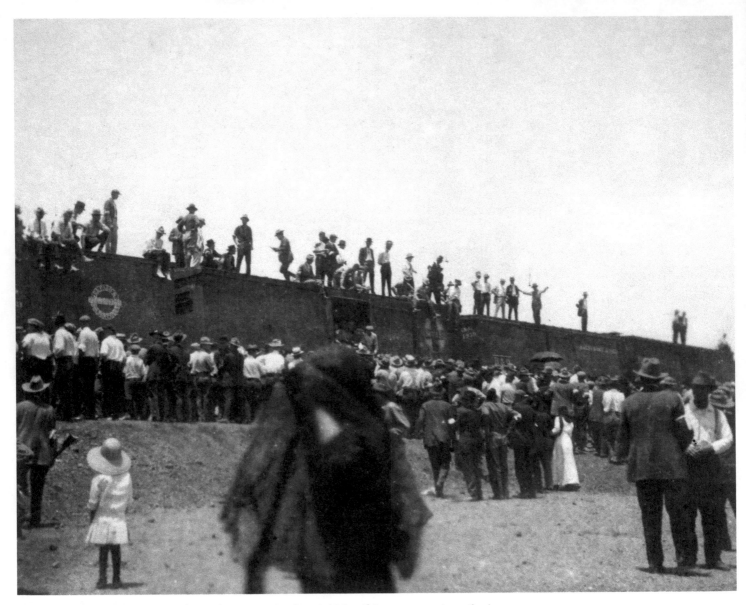

The Bisbee Deportation occurred on July 12, 1917, when 1,186 striking copper miners (or in some cases, men who were thought to be strikers) affiliated with the Industrial Workers of the World were rounded up by fellow citizens and forced into waiting boxcars. The boxcars were then pulled some 200 miles into the New Mexico desert and abandoned. This event not only shocked the miners of Arizona but impacted labor union activities throughout the United States.

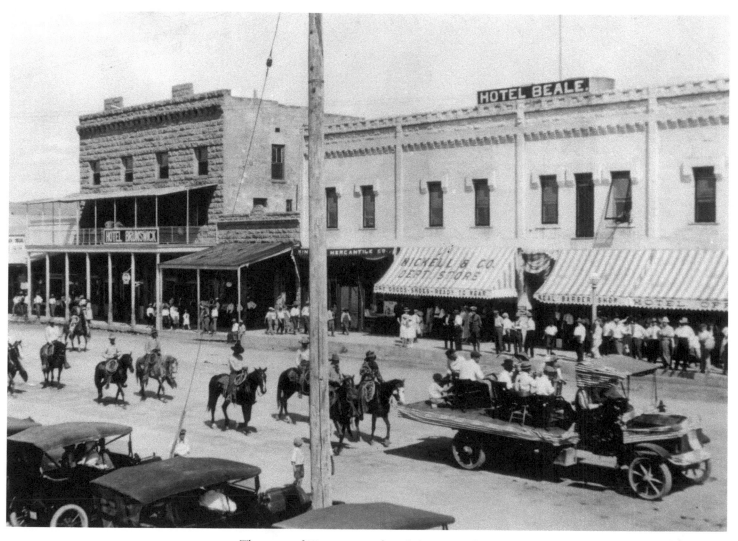

The town of Kingman was founded in 1882 along a newly constructed line of the Atlantic and Pacific Railroad in northwestern Arizona. The rail track followed the alignment for a wagon road first suggested by Lieutenant Edward Beale when he explored the 35th parallel in Arizona for the United States Army in the late 1850s. Beale used camels to help transport his men and goods through this rugged area. By 1919 a parade truck was rolling down the streets of Kingman.

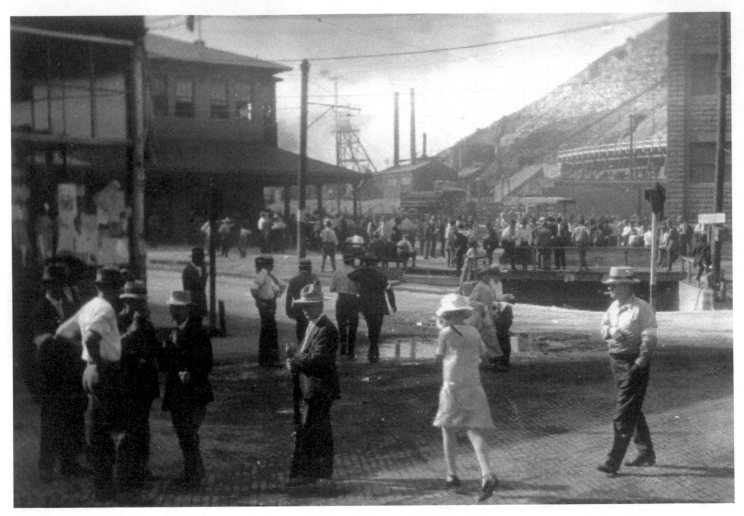

During the Bisbee Deportation, the men involved in rounding up striking miners wore white armbands to identify one another.

Modern Arizona Takes Shape

(1920–1939)

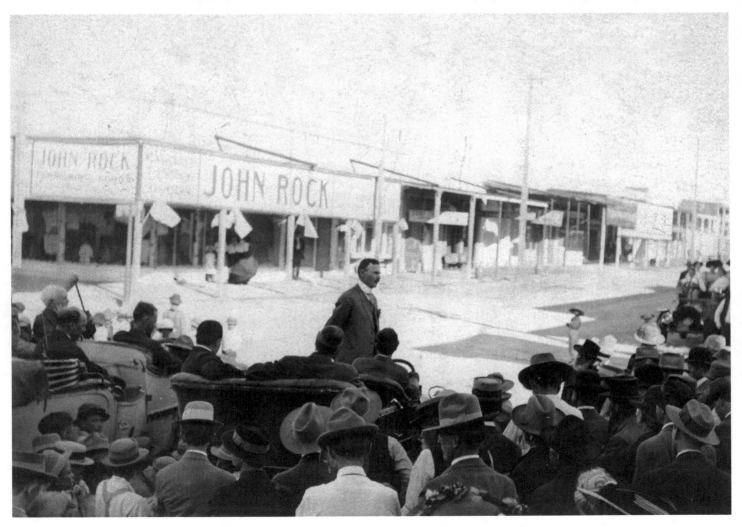

Tombstone was in trouble by the 1920s. The mines had long been flooded, and the "town too tough to die" was struggling to keep its citizens and few remaining businesses. Tombstone's once booming population had dwindled to less than a thousand folks. Here a small crowd of those remaining citizens listen to a local official speak while standing on famous Allen Street.

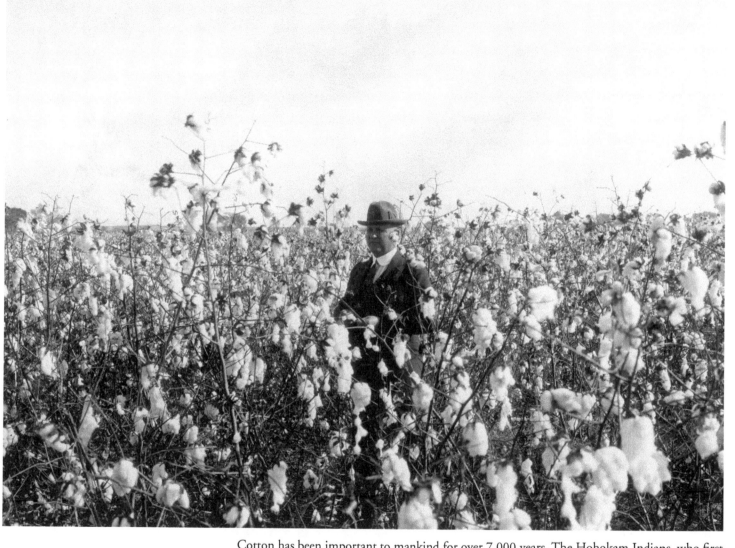

Cotton has been important to mankind for over 7,000 years. The Hohokam Indians, who first inhabited the Salt River Valley in 300 B.C., grew cotton and used it in their daily lives. In 1916 an executive with the Goodyear Tire and Rubber Company, Paul Litchfield, was sent to Arizona to buy several thousand acres of desert land and launch the subsidiary Southwest Cotton Company. The firm grew long-staple pima cotton to be used in Goodyear automobile tires. The man shown here around 1920 is standing in a cotton field in Mesa.

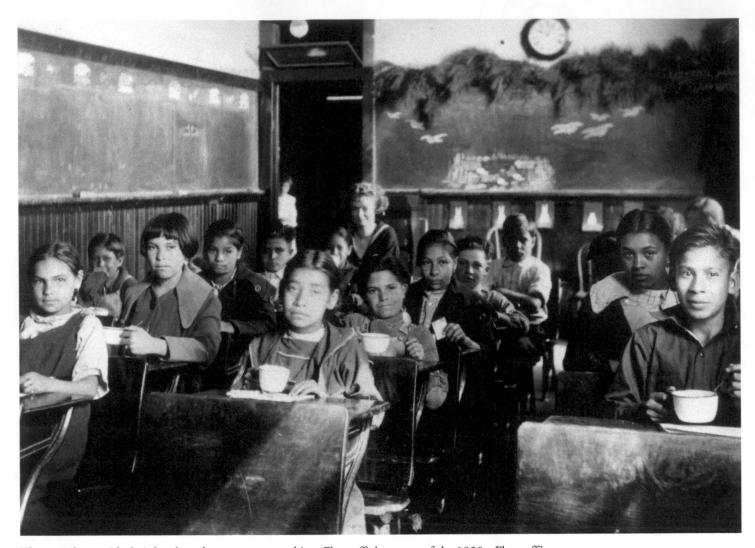

These students with their bowls and spoons are seated in a Flagstaff classroom of the 1920s. Flagstaff's original log-cabin school was built in 1883 and located halfway between the saloons of Old Town and the saloons of New Town. Local citizens built the school far enough away from the two districts' saloons to ensure that no bullets from cowboys firing their guns in "anger or celebration" would endanger the children.

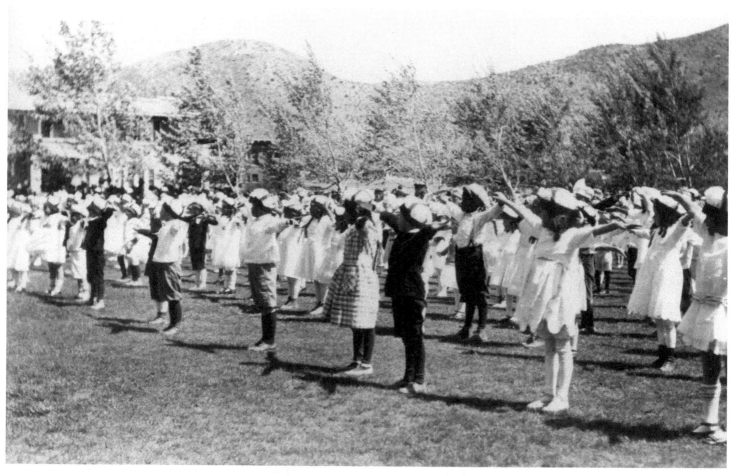

A group of children go through their morning exercises at a school in Bisbee in the 1920s.

A man with a horse and a gun was a common sight in early Arizona. Here a rider near Cave Creek in the 1920s takes a break from the saddle.

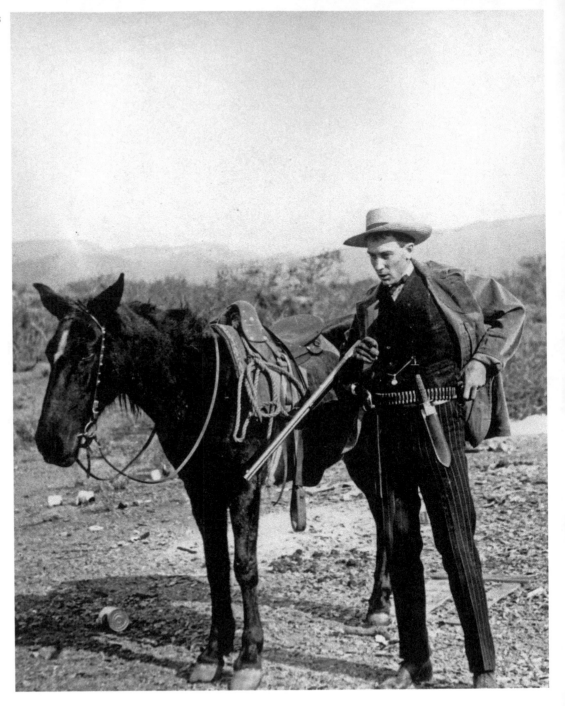

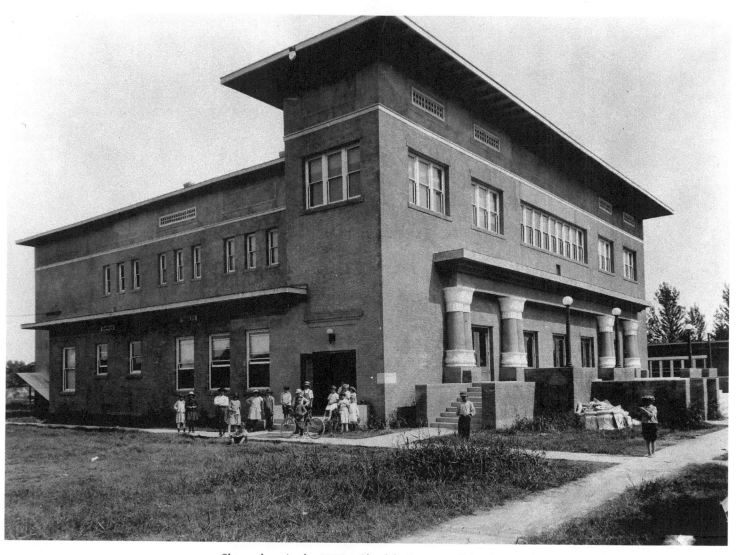

Shown here in the 1920s, Glendale Grammar School opened in 1895 to serve the rapidly growing community northwest of Phoenix. From across the Valley of the Sun, families in search of a better education for their children were drawn to the school. Today Glendale Grammar School is known as Landmark Elementary School and still serves the children of the community.

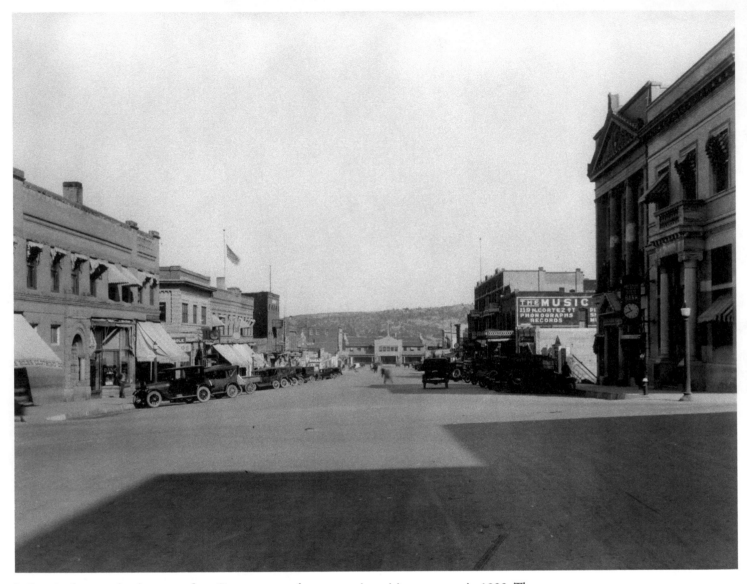

LeRoy Anderson, a local attorney from Prescott, started a community-spirit movement in 1923. The "jewel in the mountains," as Prescott was then called, needed to cultivate the arts and promote local interest in developing city parks, and also invest in infrastructure such as hospitals and good roads, Anderson advised. This view shows Prescott around that time.

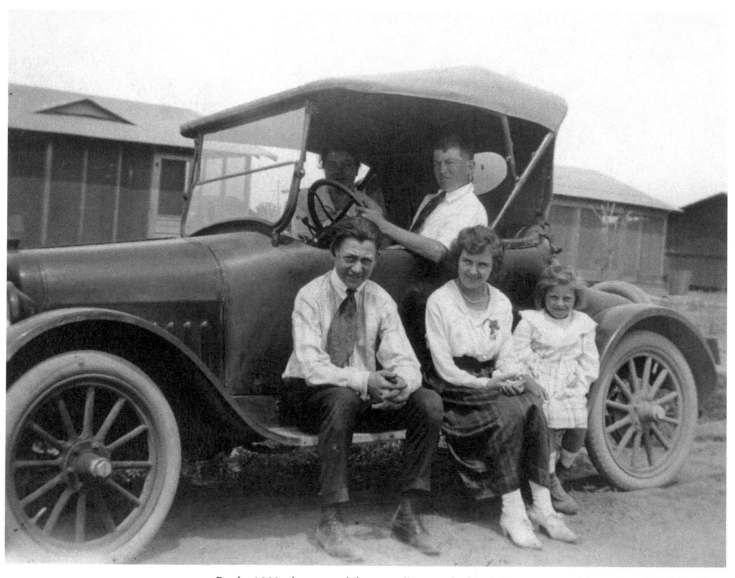

By the 1920s the automobile was well entrenched in Arizona communities such as Glendale, where these folks were most likely photographed. Established in 1892, Glendale was located just a few miles west of where William H. Bartlett homesteaded a 640-acre fruit farm in 1886.

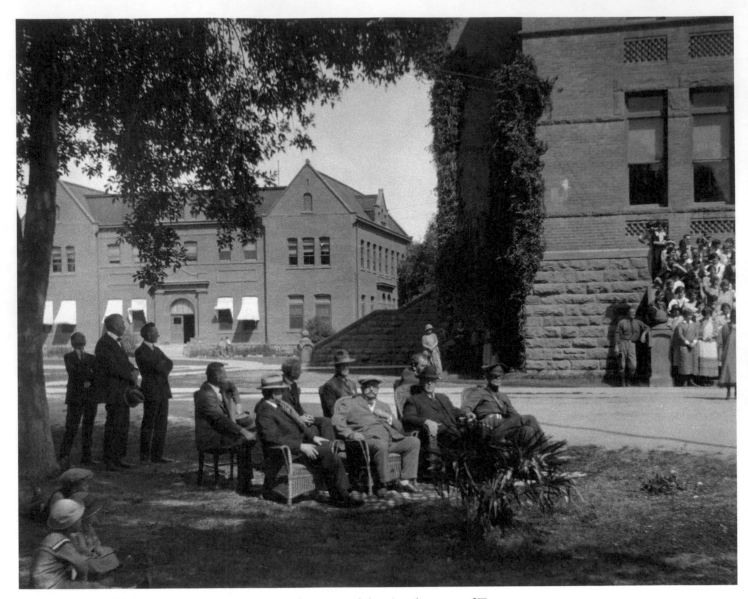

Governor George W. P. Hunt (second from left in the front row of chairs) and a group of Tempe businessmen visit the Tempe Normal School. By the time this 1924 photograph was taken, Hunt was serving his fourth two-year term as governor of Arizona. He would serve a total of seven terms.

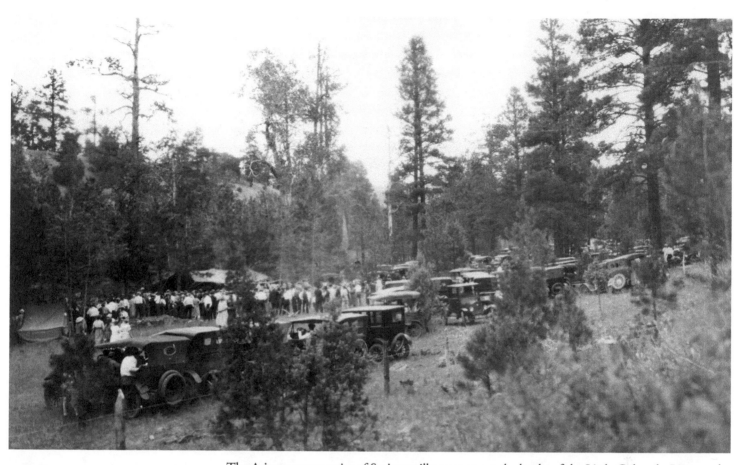

The Arizona community of Springerville grew up on the banks of the Little Colorado River at the eastern base of the White Mountains. In 1879 Henry Springer's Trading Post provided goods and supplies for the ranchers and lumberjacks of the area. The surrounding area is known as Round Valley and is just ten miles north of the Apache-Sitgreaves National Forest, no doubt the location of this 1924 barbecue.

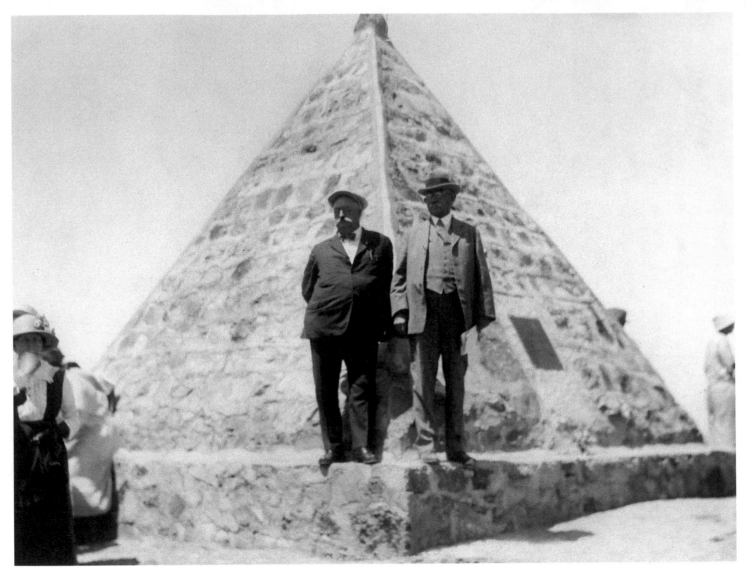

Charles Poston is known as the "Father of Arizona" for his efforts in persuading the United States Congress and President Abraham Lincoln to create the Territory of Arizona. When he died in 1902, Poston was buried under a concrete pyramid near Florence overlooking the Gila River. In this 1925 scene, Governor George W. P. Hunt (left) is visiting Poston Butte, the burial site of the Father of Arizona.

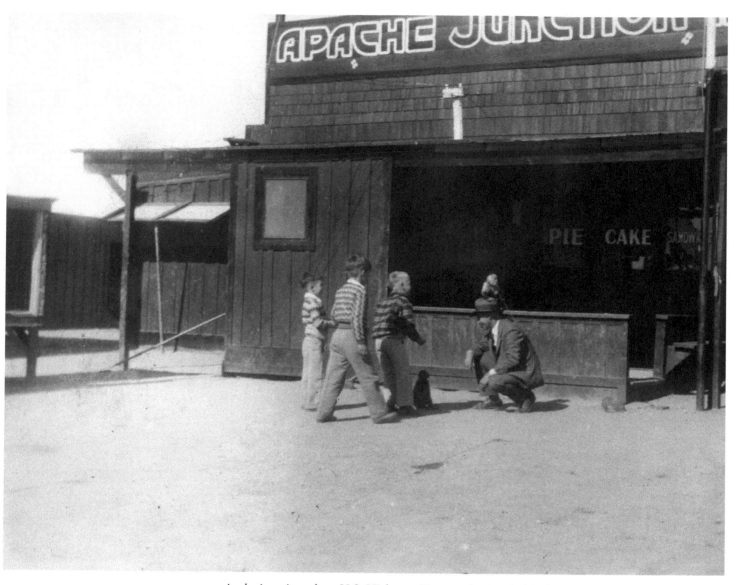

At the junction where U.S. Highway 60 meets the Apache Trail, a small community of stores and gasoline stations called Apache Junction sprang up at the base of the mighty Superstition Mountains. Travelers who followed Highway 60 arrived at the mining towns of Superior, Miami, and Globe. Those who followed the Apache Trail arrived at Roosevelt Dam. Children, too, could enjoy a stop at this oasis junction in 1926.

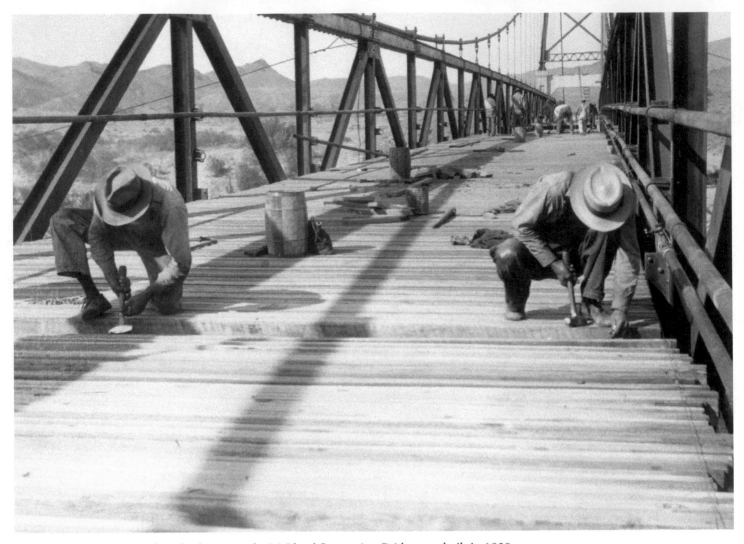

The Dome Suspension Bridge, also known as the McPhaul Suspension Bridge, was built in 1928 to link the towns of Yuma and Quartzsite. It was the longest suspension bridge in Arizona at the time, with the main span extending to 798 feet. The bridge's roadway was made of wooden planks, as shown in this image.

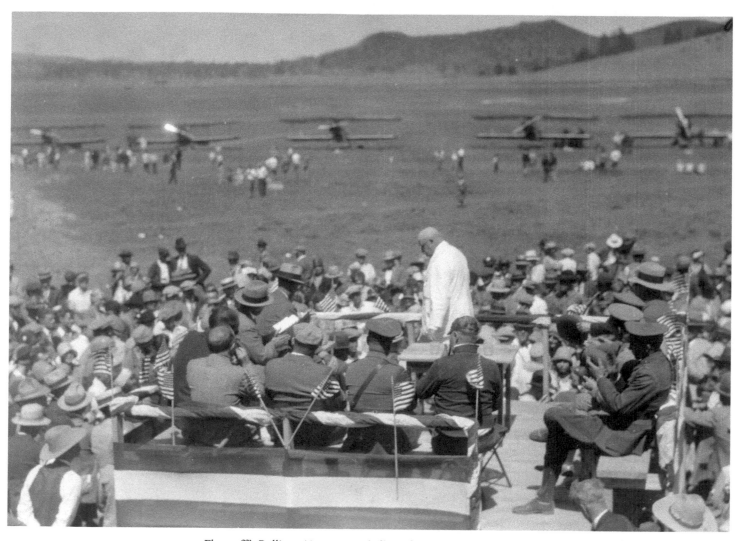

Flagstaff's Pulliam Airport was dedicated in 1928, the year Flagstaff became incorporated. The airport is located four miles from the downtown business district. Here Governor George W. P. Hunt and the citizens of Flagstaff celebrate the opening of the new airport.

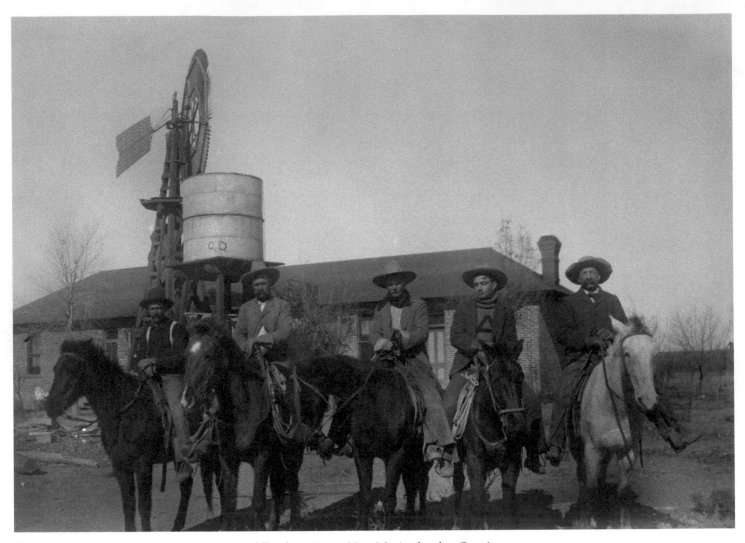

The Lazy B Ranch near Duncan, Arizona, straddles the Arizona–New Mexico border. Growing up on the Lazy B, a young girl named Sandra Day learned the ways of a 1920s Arizona ranch. In 1981, Sandra Day O'Connor became the first woman to serve as a justice of the United States Supreme Court. This photo shows her father, H. C. Day (at far right), and some of the ranch cowboys.

By the early 1930s the population of Tombstone had dropped to less than 150 people. The "town too tough to die" was truly at death's door. This 1930s photo shows the broken-down streets and dilapidated buildings of the most famous of Arizona's Wild West towns.

On March 4, 1930, President Calvin Coolidge addressed a crowd of citizens in Globe after dedicating a nearby dam named in his honor. Coolidge Dam stopped the flow of the Gila River and created San Carlos Lake some 31 miles from downtown Globe. The dam is located on the San Carlos Indian Reservation and was a part of the San Carlos Irrigation Project.

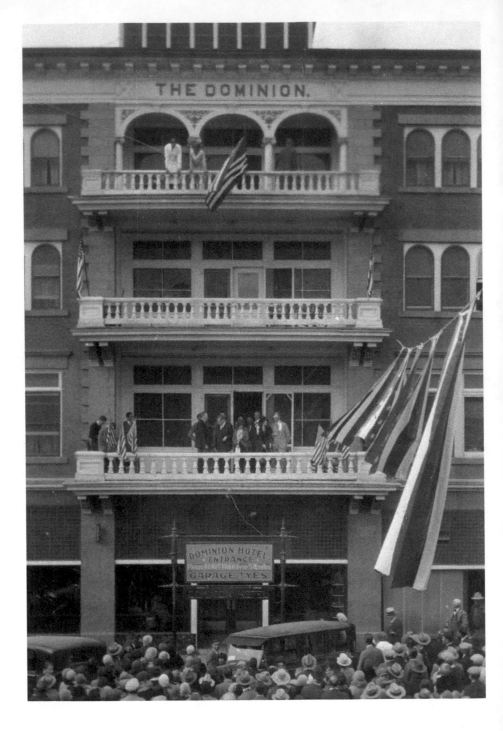

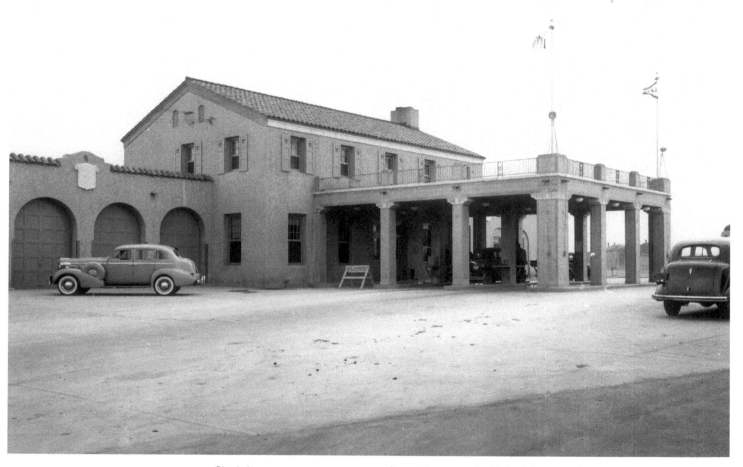

Six Arizona towns serve as ports of entry between the United States and Mexico. Most of them were established shortly after the Gadsden Purchase of 1854 and, with few exceptions, have been sites where commercial entities, families, and friends have always crossed peacefully. This border station and customs house in Douglas was one of the points where United States and Mexico citizens moved back and forth during the 1930s.

Known for its unique entry under an arching, split tree trunk, the Museum Club of Flagstaff is regarded by many as Arizona's premier roadhouse and western dance club. Built in 1931 along Route 66, the club with its large wooden dance floor has long provided fun outings for both the Arizona cowboy and the politician. Even Governor George W. P. Hunt showed up to celebrate its opening.

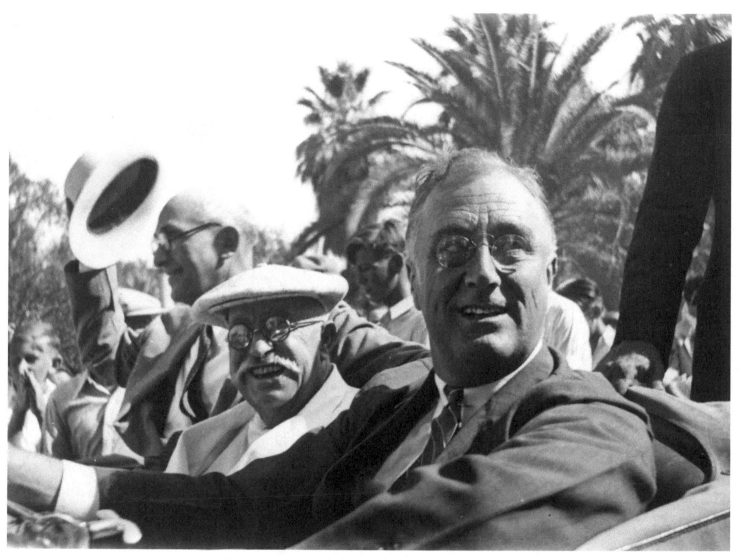

Riding in an open convertible with Governor George W. P. Hunt, presidential candidate Franklin D. Roosevelt greets Phoenix residents during a campaign visit on September 25, 1932.

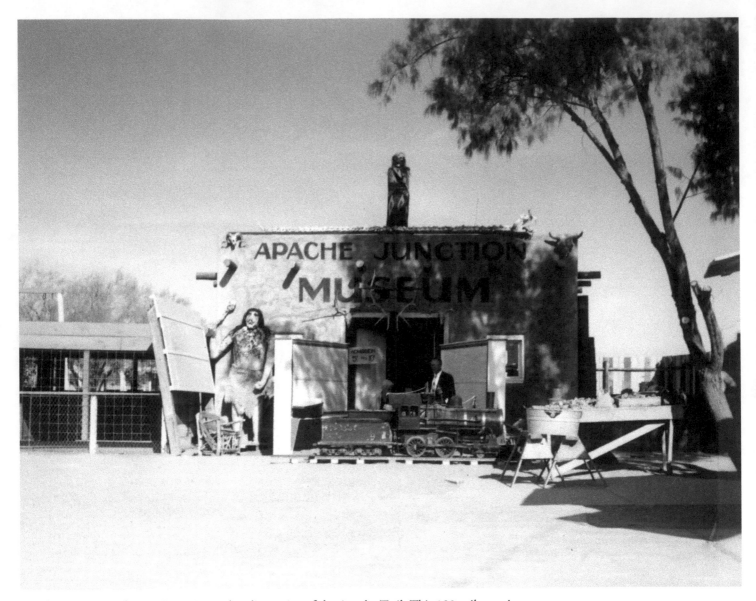

Apache Junction is the starting point and ending point of the Apache Trail. This 120-mile scenic roadway was originally built to move construction materials from Phoenix to the Roosevelt Dam site. In 1915 tourists began using the trail to travel through some of Arizona's most rugged wilderness. A stop at this 1934 museum prepared tourists for the Apache Trail experience.

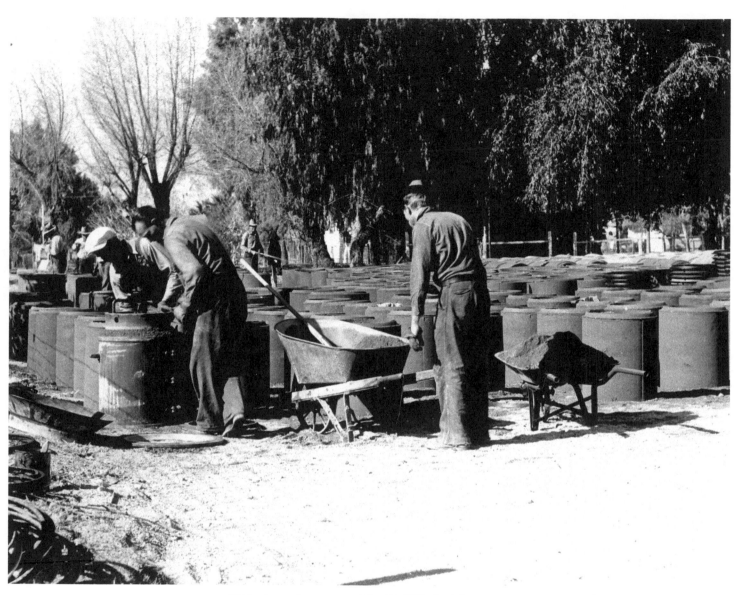

This photo shows men of the Civil Works Administration, a New Deal program started in 1933, hard at work on a project in Glendale. The Civil Works Administration lasted only five months, but a similar program, the Civilian Conservation Corps, completed many projects in Arizona. From the beautiful headquarters of Colossal Cave Mountain Park near Tucson to the trails cut through the Grand Canyon, the CCC built many of the park and recreation facilities enjoyed in Arizona today.

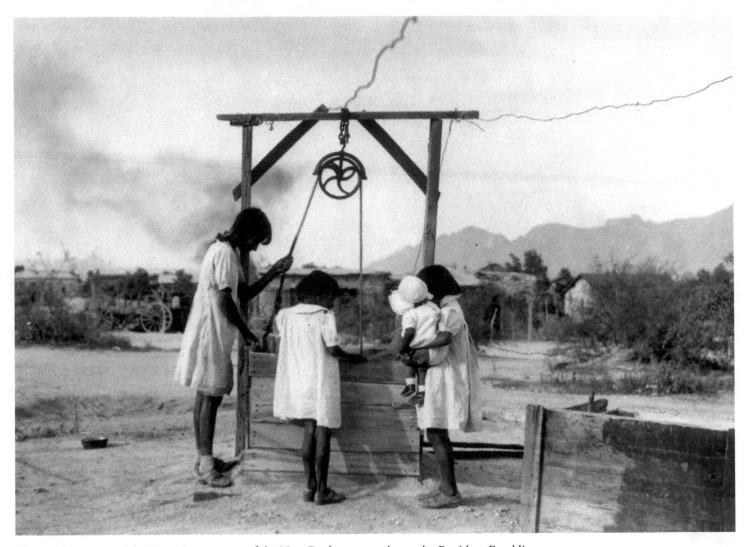

The Works Progress Administration was one of the New Deal programs begun by President Franklin
D. Roosevelt during the 1930s. Its mission was to provide jobs and income for the unemployed
during the Great Depression. The WPA built many roads and public buildings in the towns and cities
of America. These young girls are drawing fresh water from a new well dug by WPA workers on what
was then called the Papago Indian Reservation south of Tucson.

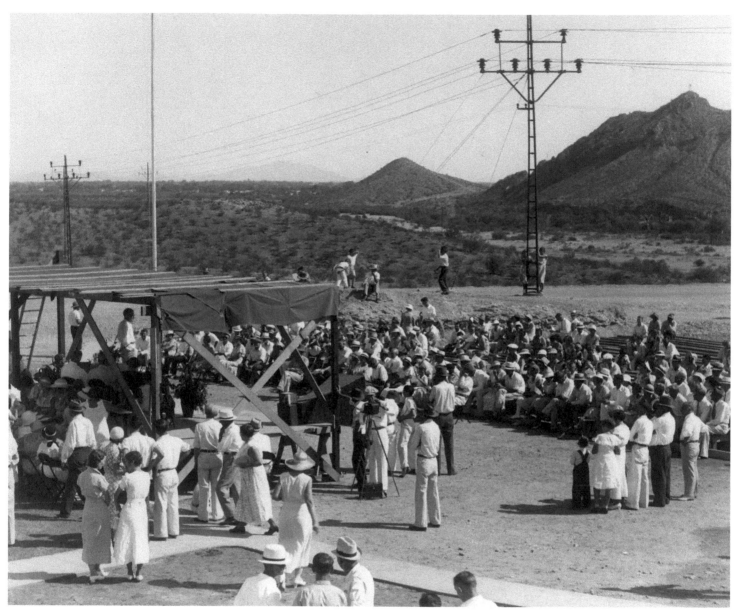

The Tuberculosis Welfare Sanatorium in Tempe was built by the Civil Works Administration and dedicated in 1934, with these folks attending. The 100-bed sanatorium was intended for patients in need of early care or with cases deemed curable. Nationwide the CWA employed a total of 12,942 men and 192 women for work on projects within the National Parks system alone.

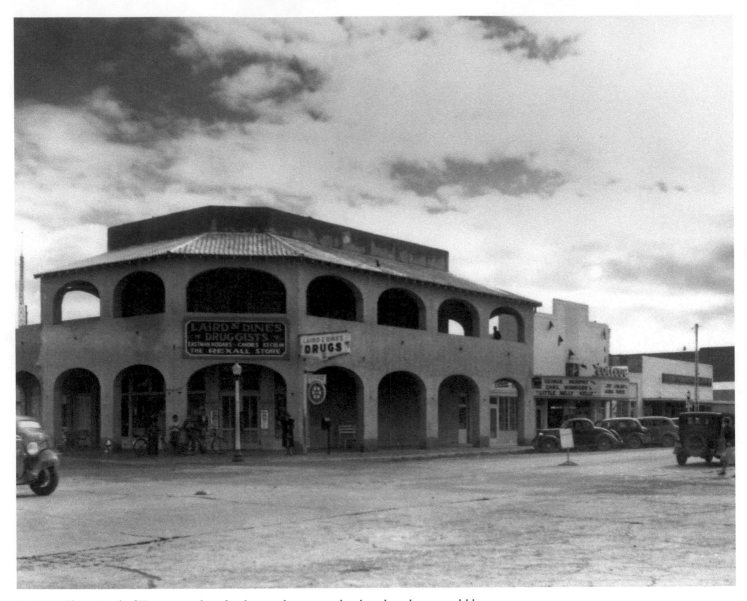

In 1897 Claire Laird of Tempe purchased a dry goods store so that her three boys would have somewhere to work. Dr. James Dines agreed to be Laird's partner and to train her boys as pharmacists. Together they established the Laird and Dines drugstore. The two-story building served the people of Tempe for 63 years. The facade of the old building still stands, but the second floor is now a Hooters restaurant.

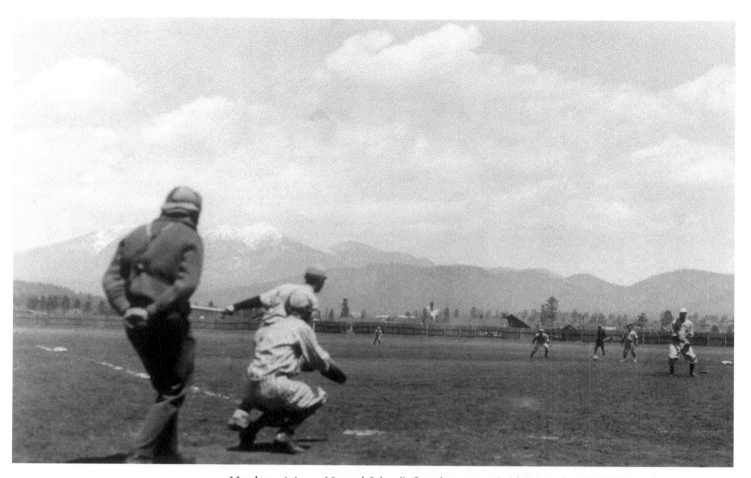

Northern Arizona Normal School's first classes were held September 11, 1899, when twenty-three students with one professor began their academic journey to become public school teachers of the Arizona Territory. Two years later, in 1901, four women made up the first graduating class. In 1925 the school became Northern Arizona State Teachers College, and Northern Arizona University in 1966. The school baseball team, the Lumberjacks, are shown playing a game around 1935.

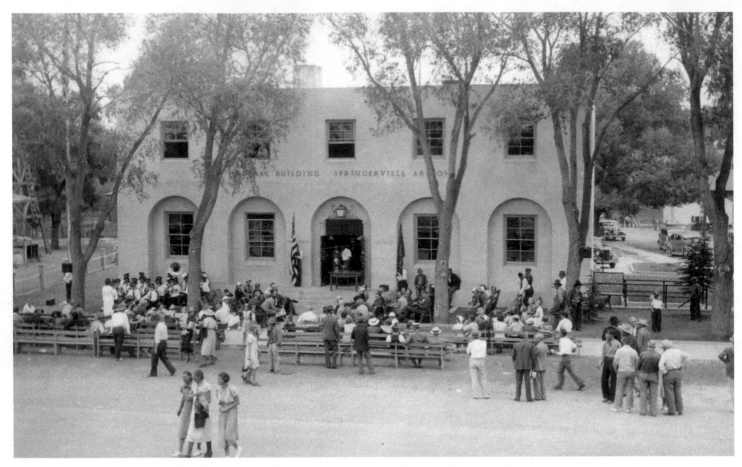

In the late 1930s the owner of the Milky Way candy company came to the Springerville area and started a Hereford ranch. His spread, which he named the Milky Way Ranch, later became part of the 26 Bar Ranch owned by John Wayne and a partner. This Springerville post office, still in service today, must have seen "the Duke" in the lobby on more than one occasion.

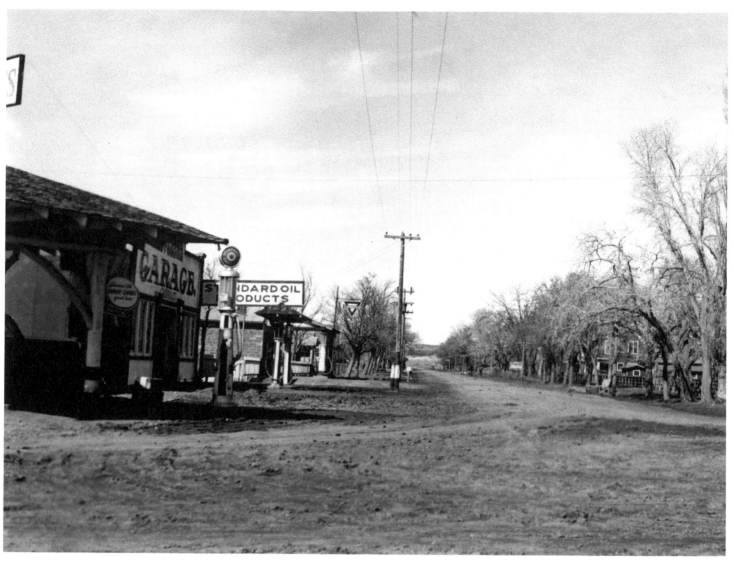

Shown here in Flagstaff in 1937, U.S. Highway 89 was created in 1926 to be a north-south pathway between the Canadian border and Nogales, Arizona. Heading north from Flagstaff through Utah, Idaho, Yellowstone Park in Wyoming, and on through Montana, today's Highway 89 passes through some of the most magnificent scenery of America. It extends 1,685 miles and is often called the "Great Western Highway."

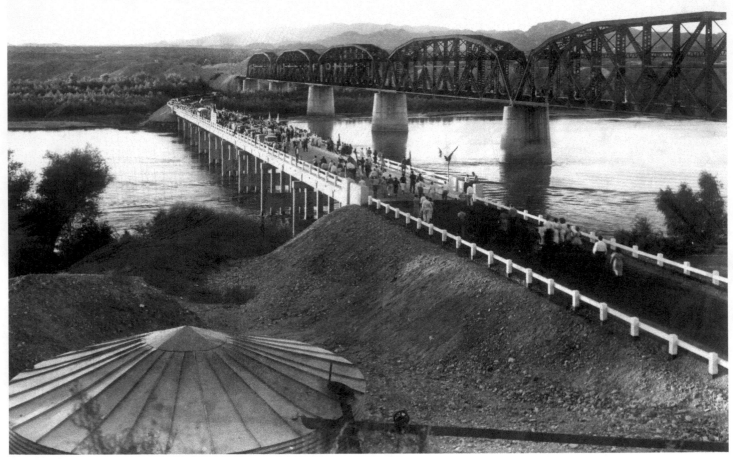

The opening of the Colorado River Bridge at Parker in 1937 ended a 27-year ferry service run by the husband and wife riverboat pilots Joe and Nellie Bush. Nellie Bush was the second woman to serve in the Arizona state legislature and was inducted into the Arizona Women's Hall of Fame in 1982.

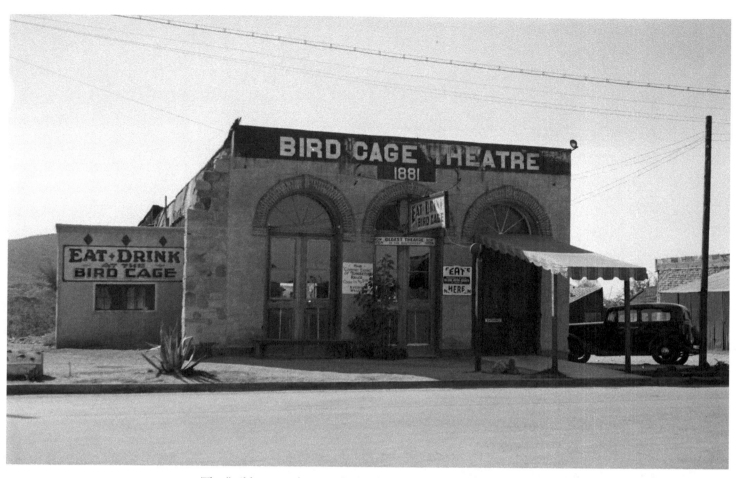

The "wildest, roughest, wickedest honky tonk between Basin Street and the Barbary Coast" is how the *New York Times* once described the Bird Cage Theatre of 1880s Tombstone. The Bird Cage served not only as a theater, but also as a gambling hall, saloon, and brothel. In the Bird Cage's eight years of operation during Tombstone's boom era, 26 people met their death there. This 1933 photo shows the Bird Cage in a quieter time.

U.S. Highway 89A was first graded in 1927, when the section between Prescott and Clarkdale was completed. By 1938, when this photo was taken near Clarkdale, the 79-mile highway was completed and paved to Flagstaff. Highway 89A passes through some of the most scenic land of Arizona, including Sedona and Oak Creek Canyon.

Desert Airfields and Postwar Growth

(1940–1970)

Guests ride the range in Wickenburg, known as the Dude Ranch Capital of the World, around 1940. Credited as the first Wickenburg dude ranch, the Bar FX Ranch opened in 1923, to be followed by the likes of the Remudas, Kay El Bar, Rancho de los Caballeros, and Flying E. The latter three ranches still welcome tourists dreaming of being a cowboy—if even for only a week.

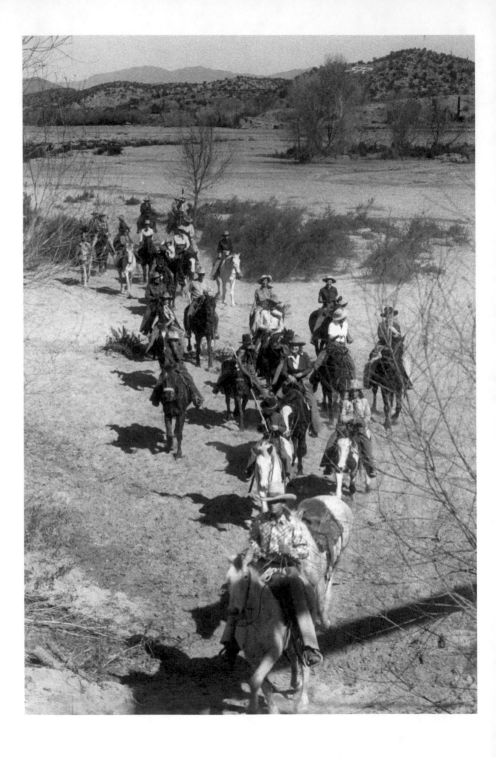

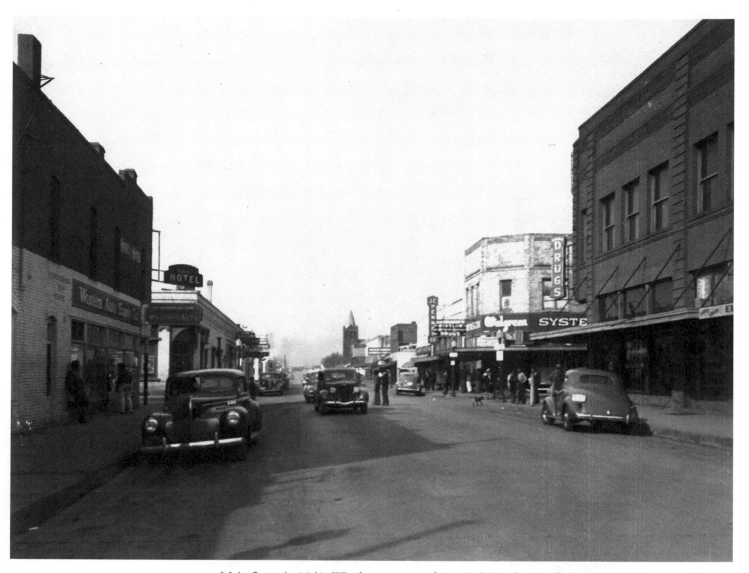

Main Street in 1940s Winslow was part of America's Mother Road, Route 66. Modern travelers can still "get their kicks on Route 66" along the 200 miles of the original road that run through northern Arizona. From the Wigwam Hotel in Holbrook, to "standing on the corner in Winslow, Arizona," to the pine trees of Flagstaff, to the gold mining town of Oatman, Route 66 adventures still await those searching for a time gone by.

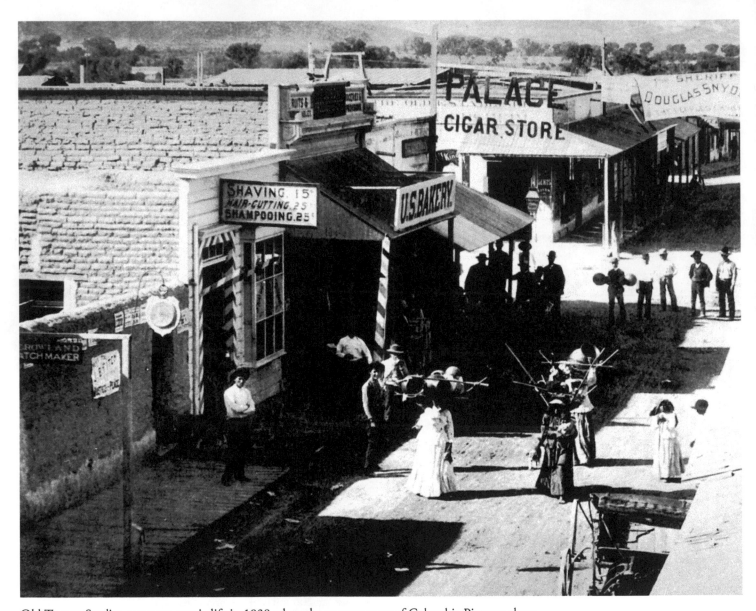

Old Tucson Studios sprang to movie life in 1939 when the management of Columbia Pictures chose a site 12 miles from downtown Tucson on which to build a replica of the town as it might have appeared in the 1860s for the movie *Arizona*. Many westerns have been filmed at Old Tucson in the years since, and the expanded studio now contains a "complete" western town of 75 buildings on a 320-acre set.

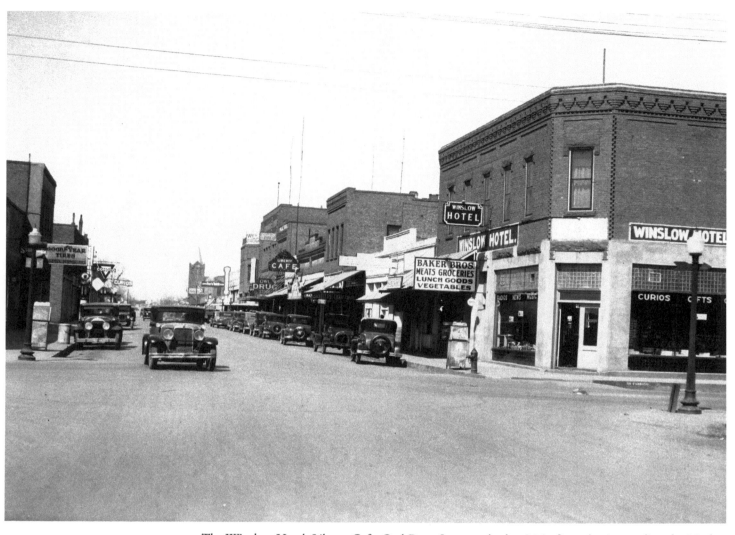

The Winslow Hotel, Liberty Cafe, Owl Drug Store, and other Main Street businesses line the Mother Road, Route 66, in downtown Winslow around 1940.

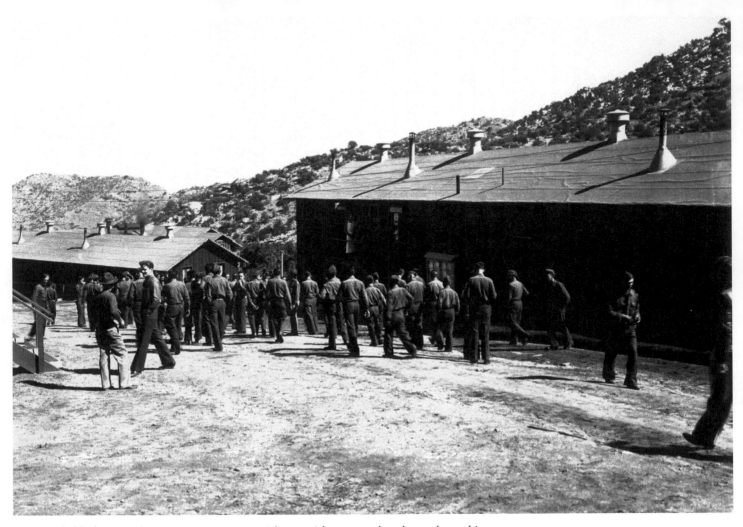

In 1932, half of America's young men ages 15 to 24 were either unemployed or only working part-time. In Arizona, some of those young men were given Civilian Conservation Corps jobs at a camp near Safford. Shown here around 1940, the Safford camp CCC workers helped on a water infiltration project involving state-owned land in the Gila River Valley.

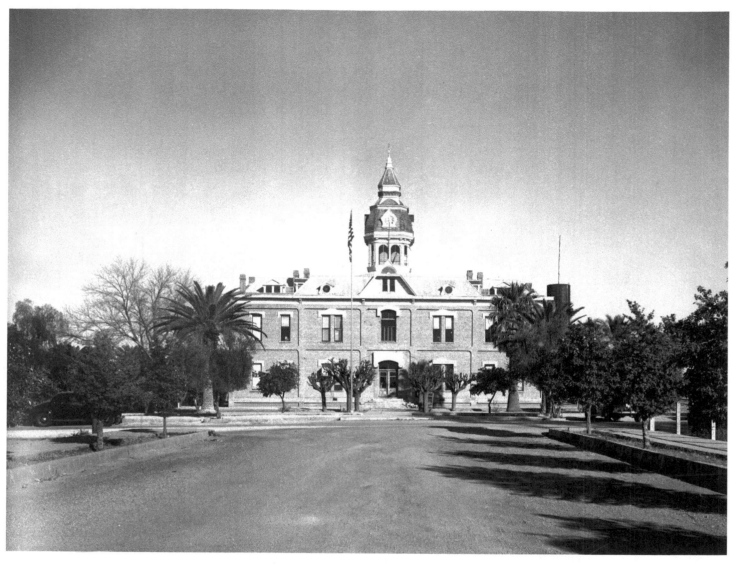

In 1891 Pinal County built a grand courthouse, seen here around 1940, to serve as the seat of county government. The building's $29,000 cost did not leave enough money for a real clock to be placed in the courthouse tower, so a pressed-metal clock face with the time set at 11:44 A.M. was mounted instead. Since the courthouse would close at noon, the 11:44 permanent setting was selected to represent a time of day when citizens coming into town would know they still had plenty of time to get their courthouse business done.

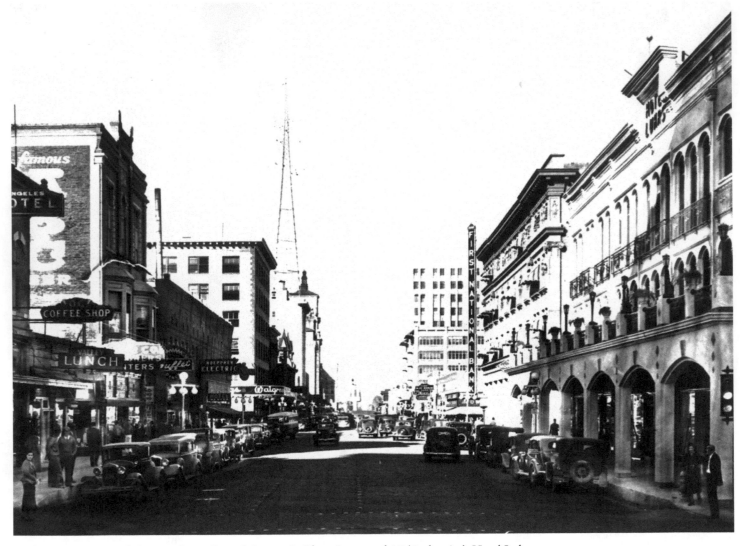

In this morning view facing north on Central Avenue in Phoenix around 1940, the city's Hotel Luhrs can be seen at right.

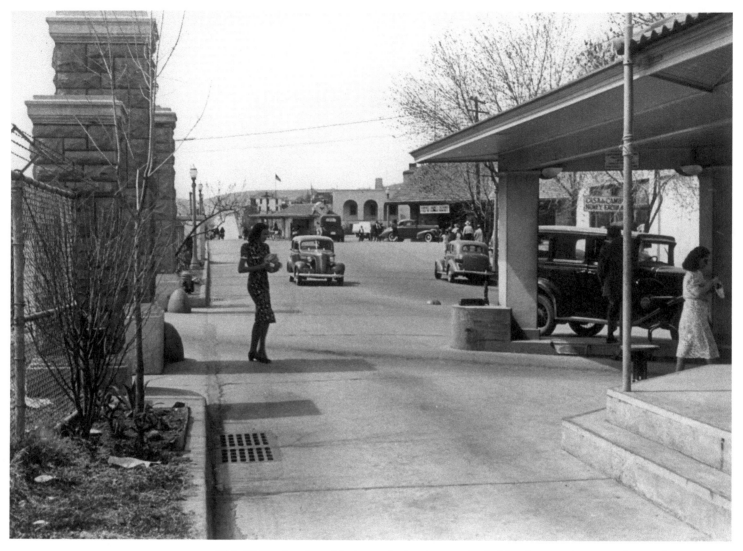

This 1940s view faces Mexico at the border crossing in Nogales, a major port of entry for commerce and people traveling between Mexico and the United States.

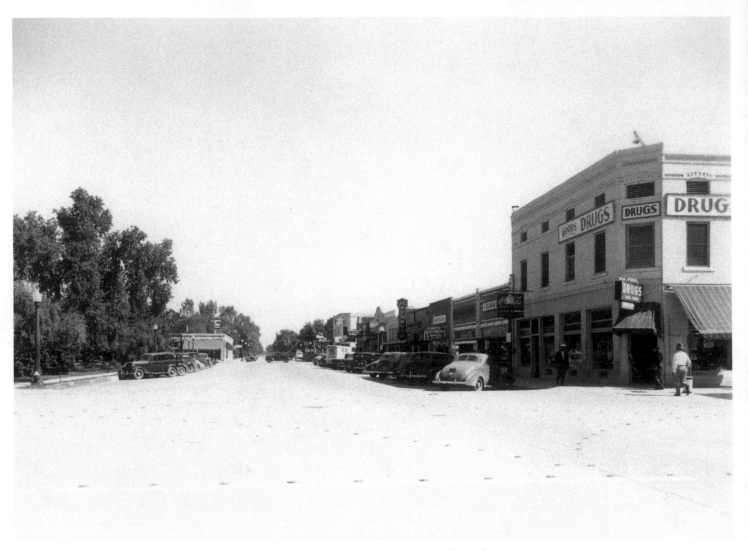

This view of downtown Glendale in the 1940s shows the local J. C. Penney store and Woods Drugs, among various other enterprises.

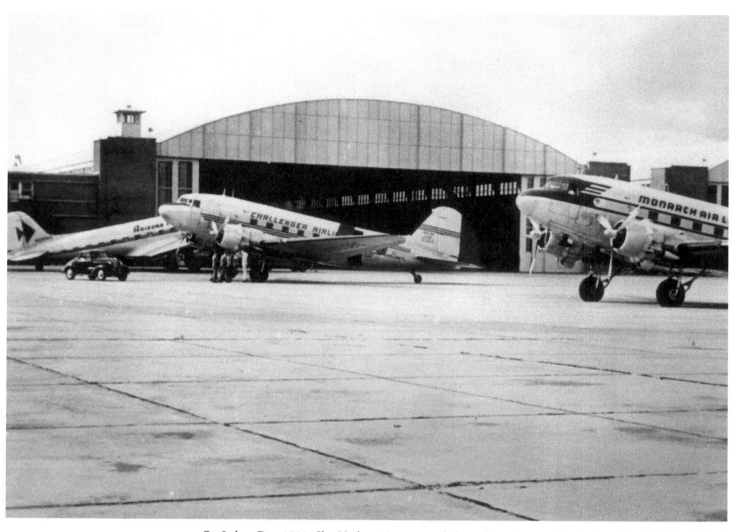

On Labor Day 1929, Sky Harbor Airport was dedicated on the same land where John Y. T. Smith had operated his hay farm in 1865. Phoenix residents called the new airport "the farm," since an airport employee had to chase the cows off the runway each time a plane needed to take off or land. The City of Phoenix bought Sky Harbor in 1935 and still operates the international airport today, as it did when these airplanes were photographed around 1950.

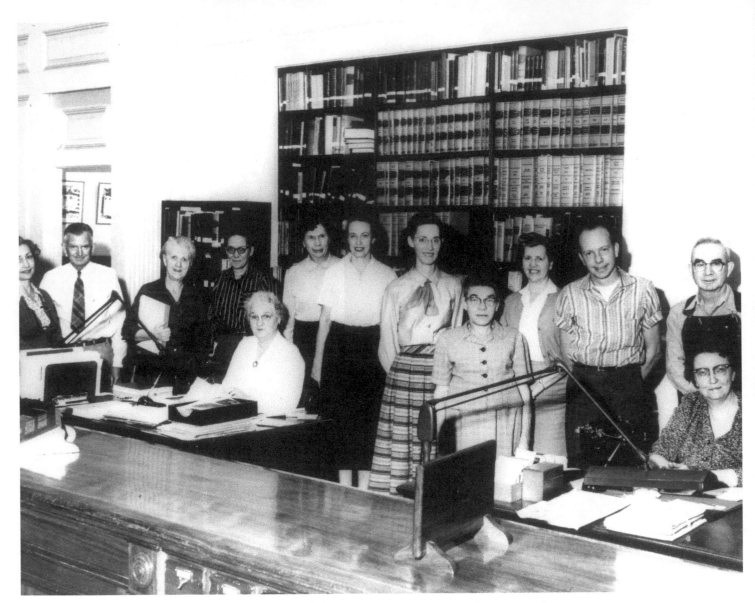

The staff of the Arizona State Library, Archives and Public Records stand ready to serve the citizens of Arizona in their searches of state records. At the time of this 1950s image, the library office was located in the old State Capitol. In 2008 the Arizona State Archives' Special Collection moved to the new Polly Rosenbaum Archives and History Building. Polly Rosenbaum served the citizens of Arizona as a state legislator from 1949 to 1995.

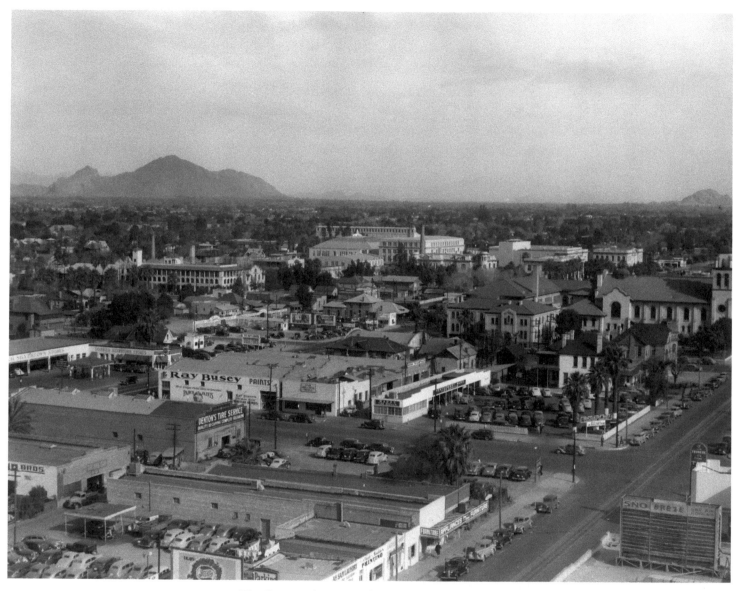

The famous Phoenix landmark Camelback Mountain is seen on the horizon in this view facing northeast from the downtown area. In 1950 Phoenix residents had to travel through mile after mile of citrus groves to reach the popular mountain. Today almost all of the citrus groves are gone, replaced by mile after mile of homes.

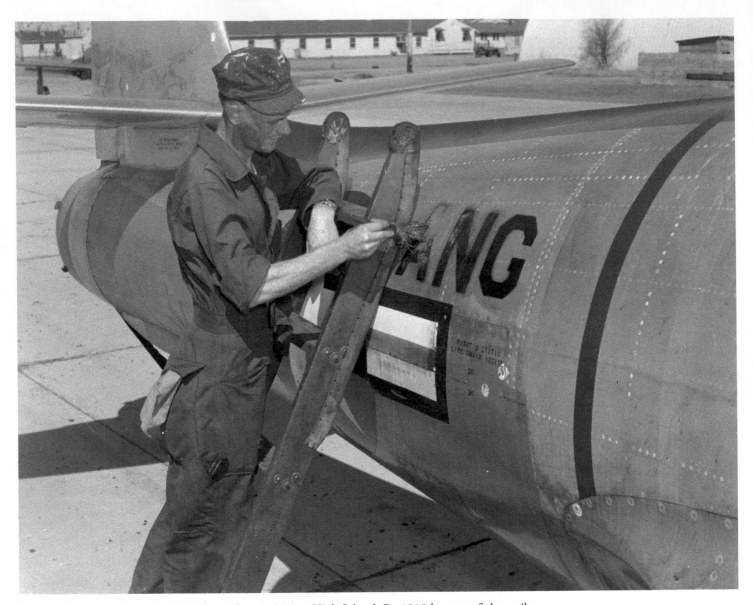

Frank Luke, Jr., graduated in 1917 from Phoenix Union High School. By 1918 he was a fighter pilot for the United States Army Air Service, flying missions over France. In 17 days of combat, young Luke shot down 14 German observation balloons and four enemy airplanes, earning him the nickname "Arizona Balloon Buster." On September 29, 1918, Frank Luke, Jr., was killed in action. Luke Air Force Base in Glendale, shown here in the 1950s, is named in his honor.

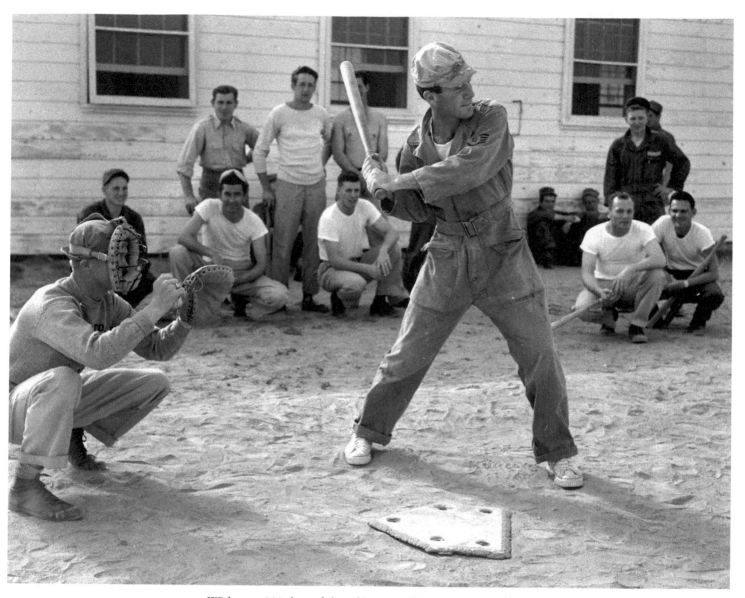

With over 300 days of clear skies annually, Arizona proved an ideal place to train young pilots during World War II. Luke Air Force Base (originally Litchfield Park Air Base) was established in 1941 when the City of Phoenix bought 1,440 acres of land in the far western part of the Valley of the Sun and leased it to the Army Air Corps for $1 a year. Here some Luke airmen enjoy a game of baseball around 1951.

After the first Harvey House appeared at a depot on the Atchison, Topeka and Santa Fe Railroad line in 1876, Fred Harvey, dubbed the "civilizer of the West," continued to build the first-class establishments until at the chain's peak there were 84 Harvey Houses. Arizona is fortunate to have two Harvey Houses still in operation—the El Tovar at the Grand Canyon, shown here in 1954, and La Posada in Winslow.

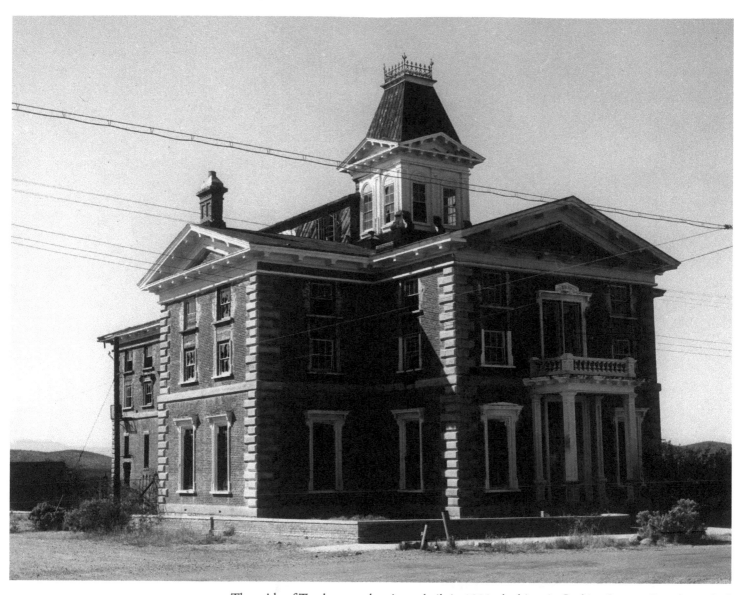

The pride of Tombstone when it was built in 1882, the historic Cochise County Courthouse had fallen into disrepair when this picture was taken in 1955. The Arizona State Parks Department took possession of the old courthouse building in 1959 and restored it to its original beauty. Today the building serves as a museum for visitors seeking to revisit the Wild West and learn the true history of Tombstone.

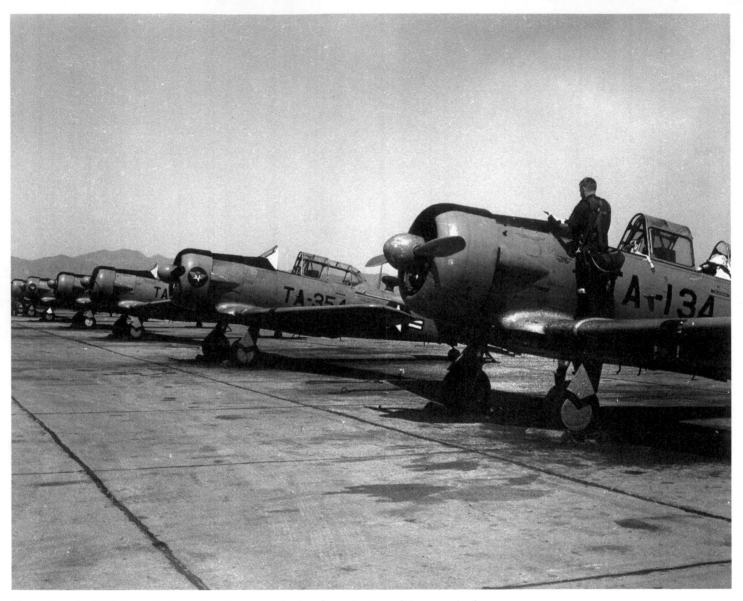

Shown here in 1955, Luke Air Force Base has trained pilots from the United States and other countries around the world for over 65 years. From the days of propeller-driven fighters to the F-16 Falcon, Luke's pilots have served America well. Today Luke Air Force Base is competing to become the primary training base for the U.S. Air Force's new F-35 Lightning fighter jet.

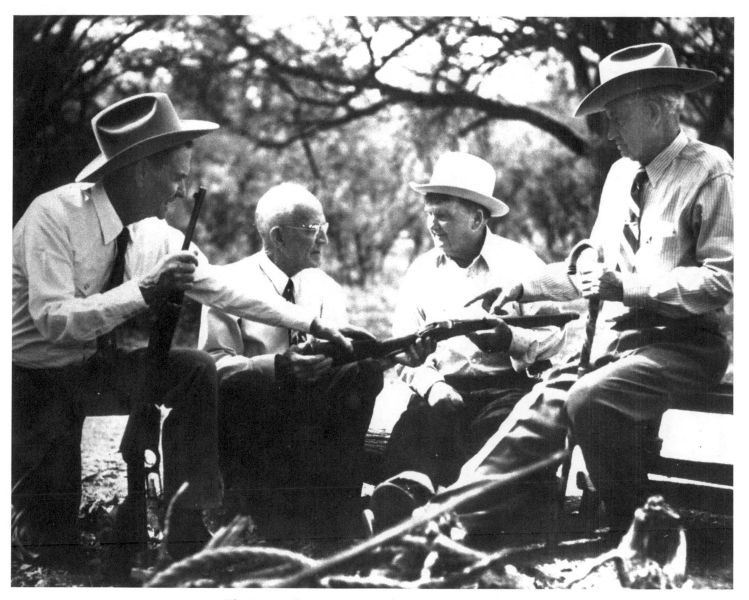

The Arizona Rangers came into being in 1901 to protect the citizens of the Arizona Territory from rustlers and other outlaws and to help prepare the territory for statehood. With a total force never larger than 26 men, the rangers covered the entire territory. They were disbanded in 1909, but the few surviving members reunited in 1957, as shown here, when the Arizona Rangers were reestablished as an all-volunteer group that serves the state even today.

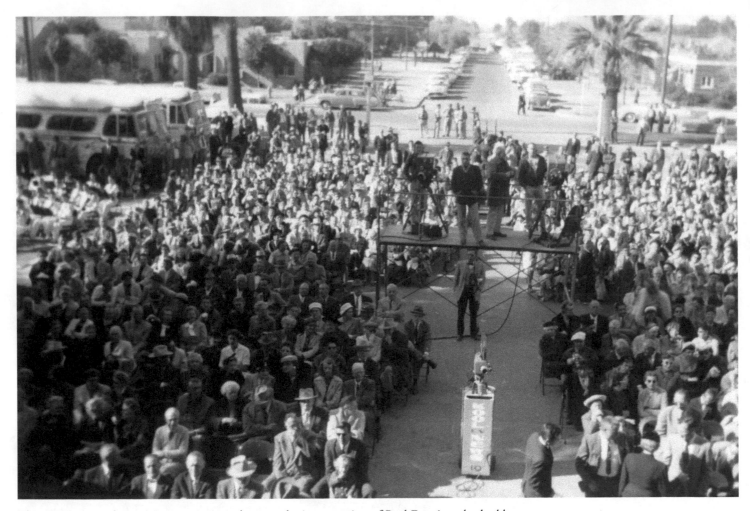

This 1959 photo shows Arizonans in attendance at the inauguration of Paul Fannin, who had been elected the 15th governor of Arizona in 1958. In 1964 Governor Fannin was elected to the United States Senate, when Barry Goldwater chose to run for president of the United States. Fannin served two terms in the United States Senate, retiring from it in 1977.

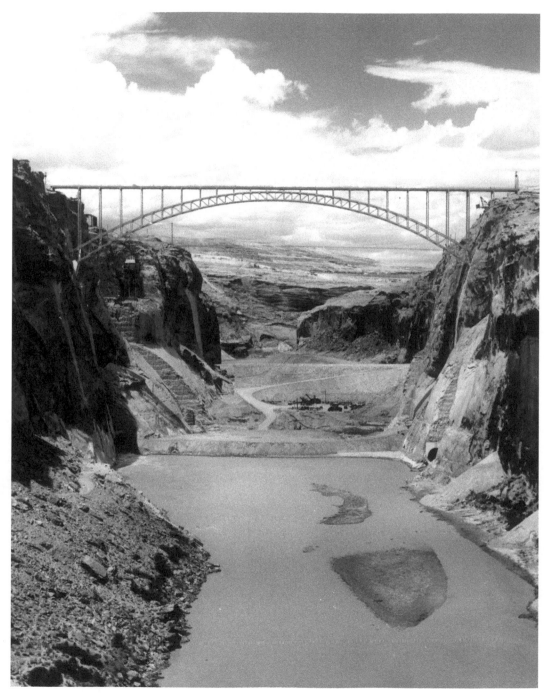

The damming of the Colorado River in northern Arizona's beautiful Glen Canyon was a highly controversial reclamation project. On October 15, 1956, the first dynamite blast shattered this high desert wilderness' calm, and the ten-year construction project had begun. Behind this great dam are held the waters of the hauntingly beautiful Lake Powell.

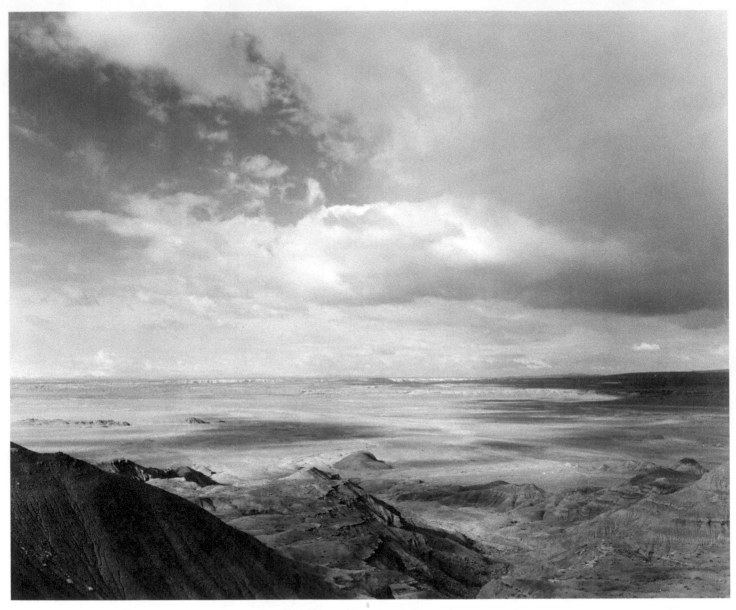

This aerial view around 1960 shows Carson Mesa, which is located on the Navajo Indian Reservation in northeastern Arizona, north of the town of Many Farms. Part of the Chinle Valley, the mesa is in an area of Arizona that contains some of the Southwest's most striking geological formations, including nearby Canyon de Chelley.

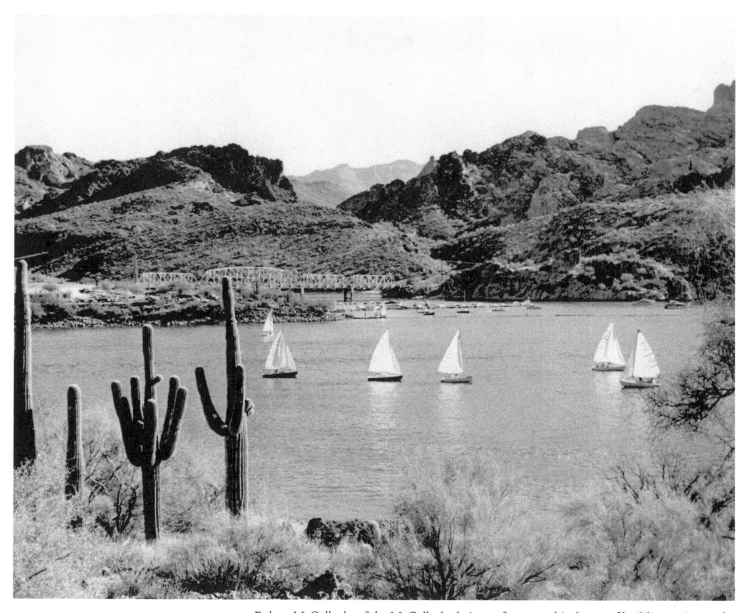

Robert McCulloch, of the McCulloch chainsaw fame, put his dream of building a city on the Colorado River into action when he bought 26 square miles of Arizona desert in 1963 for less than $75 an acre. Continuing to dream, he bought London Bridge and moved it to his new Arizona town, Lake Havasu City, where sailboats and saguaro cacti could be seen side by side.

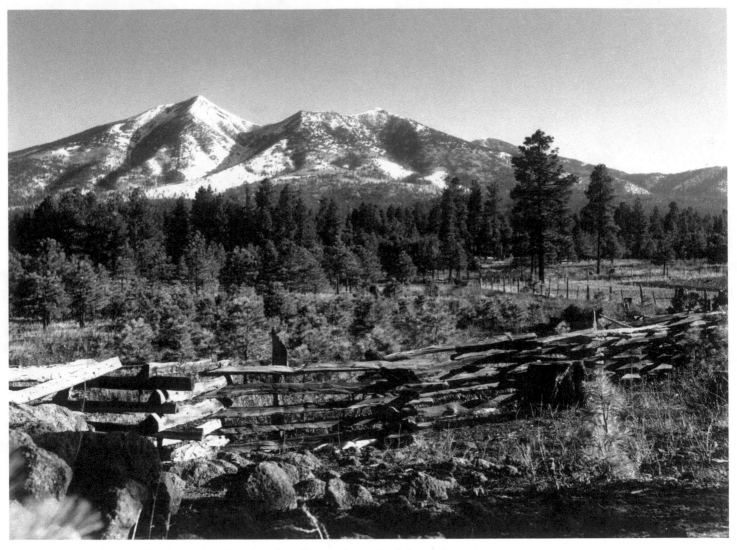

At an elevation of 12,633 feet, Humphrey's Peak is the tallest mountain in Arizona. An extinct volcano, the mountain is part of the San Francisco range located just north of Flagstaff. The 4.8-mile climb to the top, which can only be made in the summer months, allows an adventurous hiker to proclaim, "I have stood on top of Arizona!"

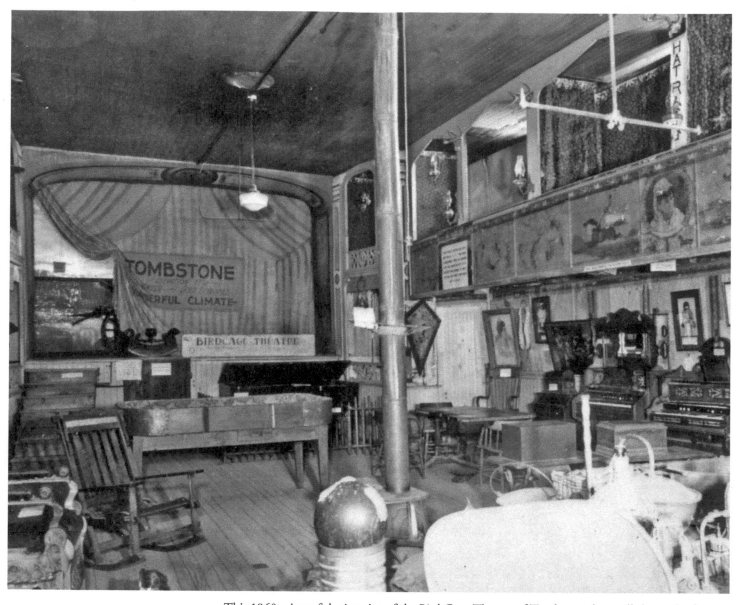

This 1960s view of the interior of the Bird Cage Theatre of Tombstone lore still shows the famous "bird cages" lining the upper-right wall. The cages held the ladies of the night who sold their pleasures 24 hours a day, 7 days a week to the Tombstone miners and cowboys of the 1880s.

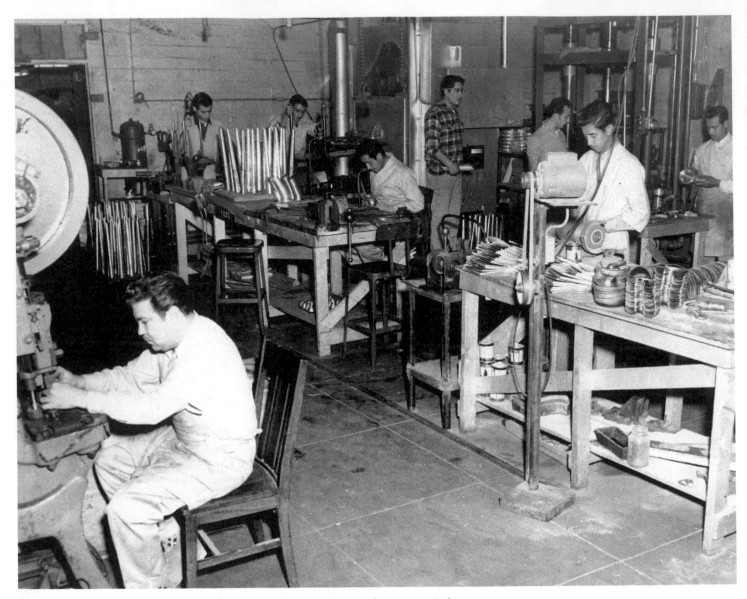

C. G. Conn, a Civil War veteran, was the founder of America's most famous musical instrument manufacturing company, located in Elkhart, Indiana. Elected to the United States Congress in 1892, Conn introduced a bill requiring every army regiment to have its own band, a law that boosted sales of Conn instruments. In 1960 the C. G. Conn firm moved the majority of its saxophone manufacturing business to Nogales, where this photo of the workshop was taken.

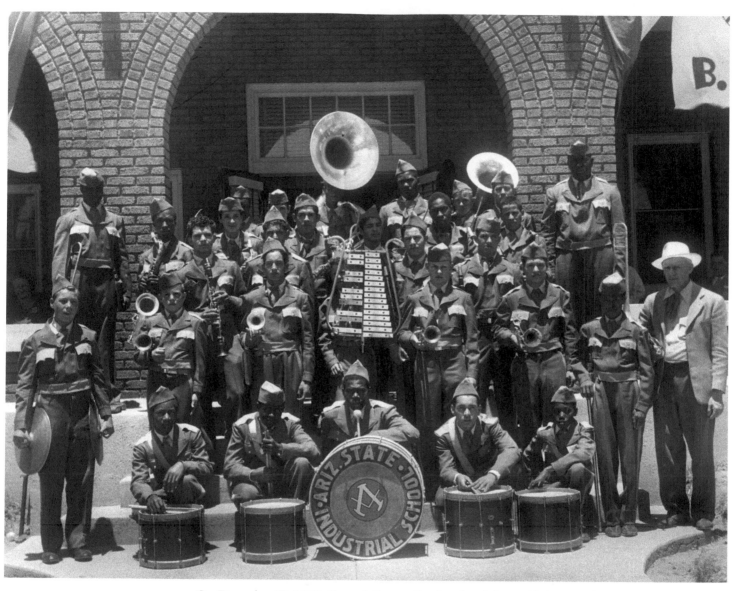

On December 19, 1872, General George Crook ordered the establishment of Fort Grant at the base of Mount Graham in southeastern Arizona. For the 11 companies of United States cavalry and infantry stationed there, the only assignment was to capture the great Apache leader Geronimo. Over the years Fort Grant served many roles, eventually becoming the Arizona State Industrial School, a reform school for boys, where the band was photographed in 1962.

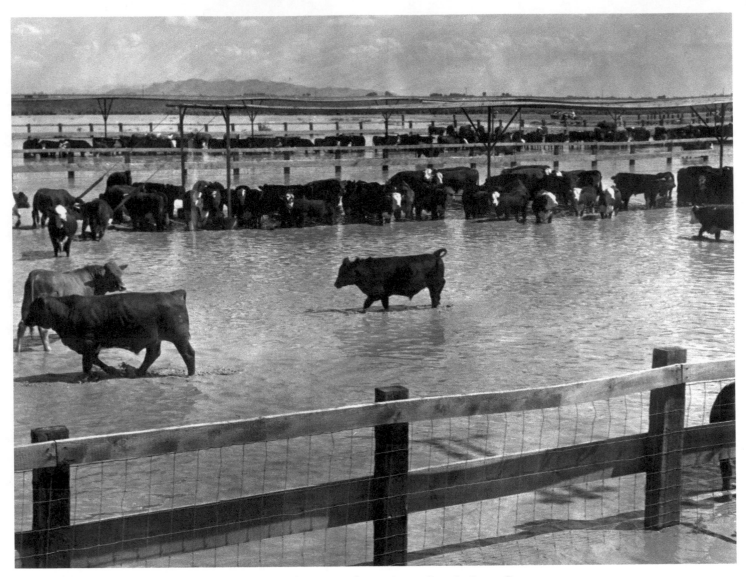

A terrible storm rolled through the Sonoran Desert in late September 1962, sending the Santa Cruz River and Santa Rosa Wash over their banks and flooding large areas of south-central Arizona. The cattle on this ranch near Eloy had to wade through the water and mud even within their feedlots.

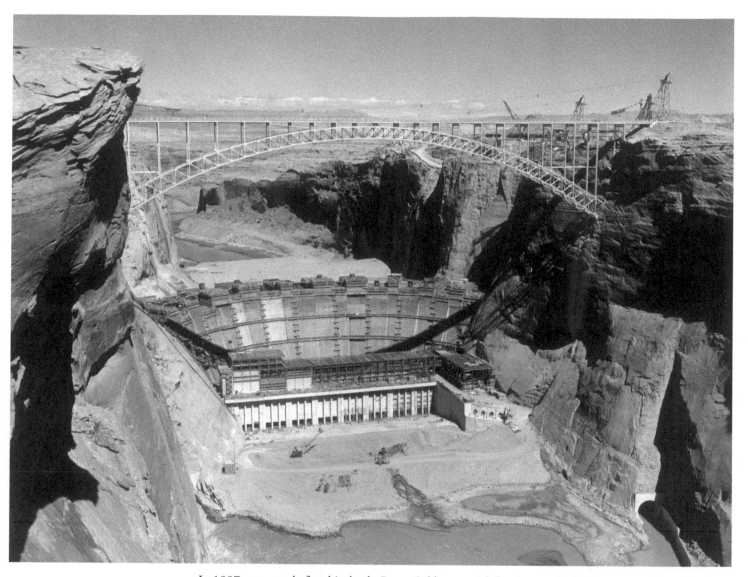

In 1997, one year before his death, Barry Goldwater said that he regretted his support and vote in favor of the construction of Glen Canyon Dam, shown here in 1962. The environmentalist author Edward Abbey spent the last years of his life lobbying for the destruction of the dam. Others argue that without the great dams to store water for the long periods of drought, the modern western cities of Phoenix, Las Vegas, and even Los Angeles would not exist. Today Glen Canyon Dam and Lake Powell remain as examples in the many debates that still rage over the damming of the rivers of the American West.

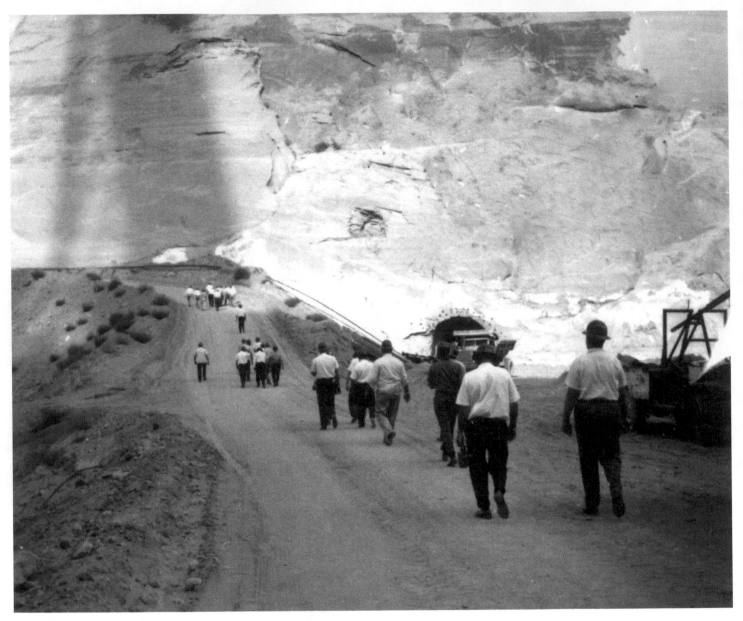

Arizona Highway Department employees are shown at the construction site of Glen Canyon Dam in 1963, the year the dam was deemed sufficiently near completion to begin backing up the waters of the Colorado River, creating Lake Powell.

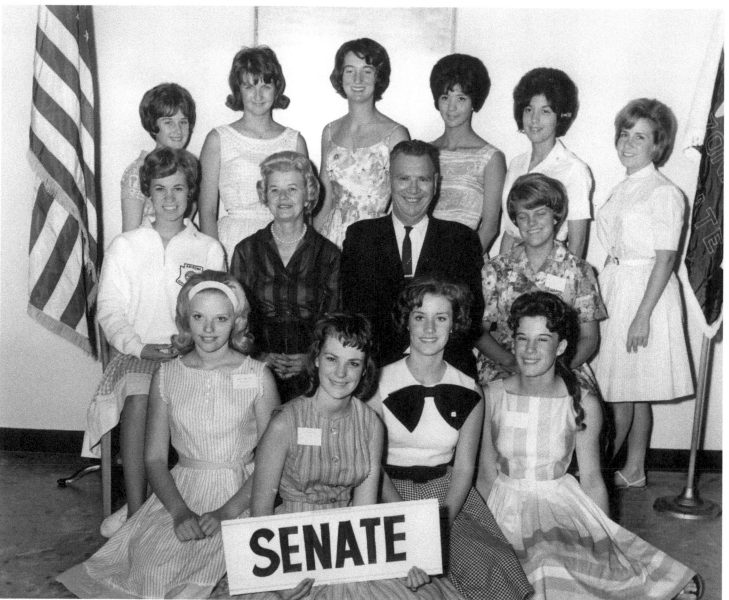

Senator Clarence Carpenter of Miami, Arizona, helps a group of students learn about the legislative process during the 1963 Arizona youth legislature in Phoenix. Miami was a struggling copper mining town in 1963, and Senator Carpenter did much to keep the Gila County towns vital.

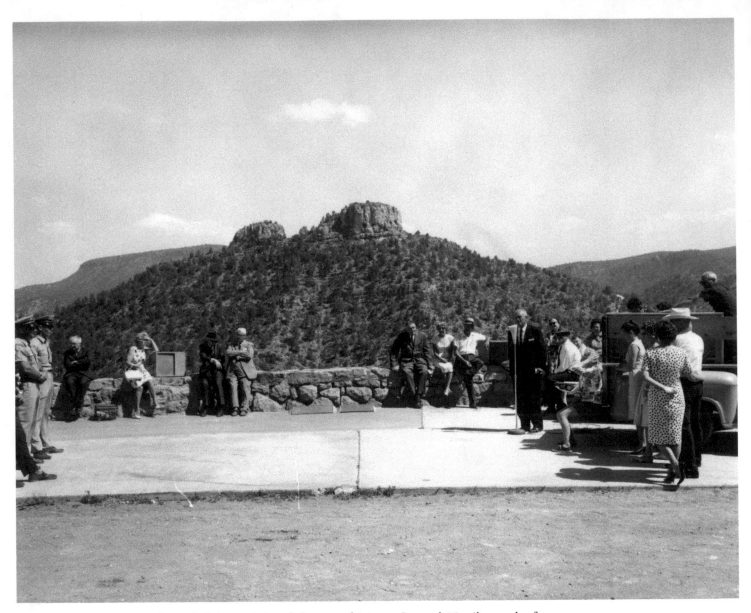

The Salt River Canyon is often called the mini Grand Canyon of Arizona. Located 25 miles north of Globe, the 2,000-foot-deep canyon offers spectacular views from Arizona Highway 77 as it winds its way from the Phoenix area to the recreational areas of the White Mountains. These folks are attending the dedication of Highway 77 in 1964. A modern bridge was constructed across the vast gorge and dedicated in 1977.

In 1913, when the Tremaine family of Cleveland became interested in ranching in northern Arizona, their agent sought out Boss Chilson to operate their new Bar T Ranch. Over the years, more rangeland was added to the Bar T holdings, including the land that surrounded the famous Meteor Crater. Here the great granddaughter of Boss Chilson frolics on the ranch in the 1960s.

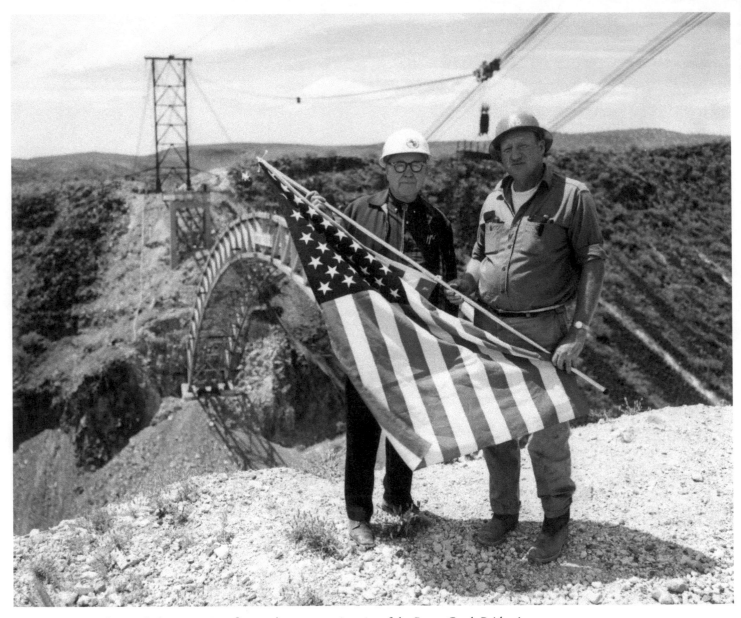

Construction workers unfurl an American flag on the construction site of the Burro Creek Bridge in 1965. Burro Creek is located some 15 miles south of Wikieup on U.S. Highway 93, a major highway between Phoenix and Las Vegas.

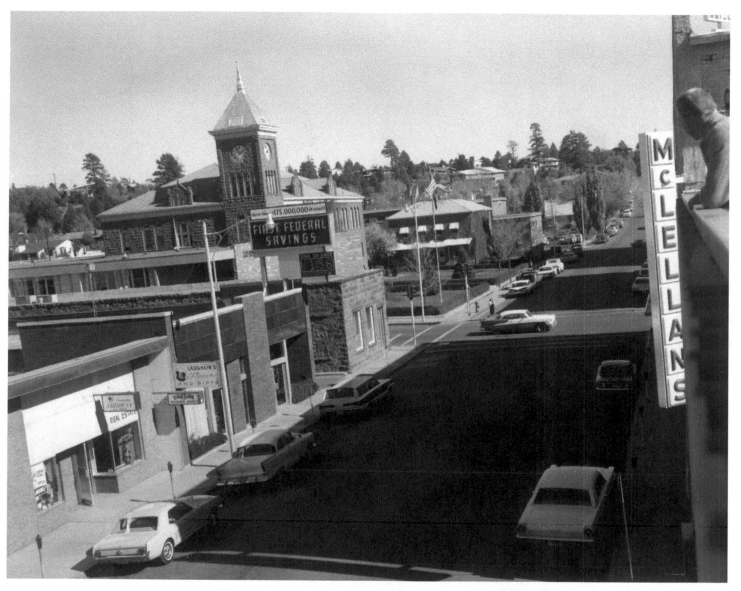

Young men atop a Flagstaff building in 1966 look east down Birch Street toward the old Coconino County Courthouse. Built in 1893, the old courthouse is still used for county offices today.

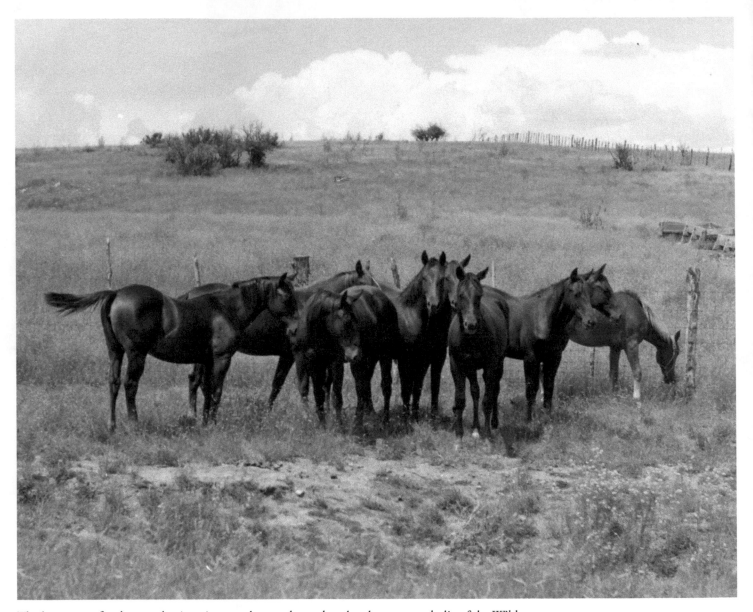

The horse gave freedom to the American cowboy, and together they became symbolic of the Wild West. Since herds of wild horses still run free in parts of Arizona, then surely too does a small bit of that era remain, ready to be discovered by modern dreamers.

For people whose "heroes have always been cowboys," Arizona is still a place where the beauty and adventure of the American West can be found and enjoyed. Come to Arizona and discover it for yourself!

Notes on the Photographs

These notes, listed by page number, attempt to include all aspects known of the photographs. Each of the photographs is identified by the page number, photograph's title or description, photographer and collection, archive, and call or box number when applicable. Although every attempt was made to collect all data, in some cases complete data may have been unavailable due to the age and condition of some of the photographs and records.

91 U.S. Highway 89
Arizona State Library,
Archives and Public Records,
History and Archives
Division, Phoenix
93-1171

92 Bridge at Parker
Arizona State Library,
Archives and Public Records,
History and Archives
Division, Phoenix
98-1579

93 Bird Cage Theatre
Library of Congress
HABS ARIZ,2-TOMB,18-1

94 U.S. Highway 89A
Arizona State Library,
Archives and Public Records,
History and Archives
Division, Phoenix
02-0958

96 Ranch Guests
Arizona State Library,
Archives and Public Records,
History and Archives
Division, Phoenix
95-9802

97 Winslow Street
Arizona State Library,
Archives and Public Records,
History and Archives
Division, Phoenix
99-0490

98 Old Tucson
Arizona State Library,
Archives and Public Records,
History and Archives
Division, Phoenix
95-1030

99 Winslow, 1940s
Arizona State Library,
Archives and Public Records,
History and Archives
Division, Phoenix
99-0501

100 Safford CCC Camp
Arizona State Library,
Archives and Public Records,
History and Archives
Division, Phoenix
96-4312

101 Pinal County Courthouse
Arizona State Library,
Archives and Public Records,
History and Archives
Division, Phoenix
95-3526

102 Hotel Luhrs
Arizona State Library,
Archives and Public Records,
History and Archives
Division, Phoenix
97-0880

103 Nogales Border Station
Arizona State Library,
Archives and Public Records,
History and Archives
Division, Phoenix
96-3766

104 Glendale Stores
Arizona State Library,
Archives and Public Records,
History and Archives
Division, Phoenix
96-4011

105 Phoenix Airport
Arizona State Library,
Archives and Public Records,
History and Archives
Division, Phoenix
99-0485

106 State Library Staff
Arizona State Library,
Archives and Public Records,
History and Archives
Division, Phoenix
95-3848

107 Camelback
Arizona State Library,
Archives and Public Records,
History and Archives
Division, Phoenix
97-0982

108 Luke Air Force Base
Arizona State Library,
Archives and Public Records,
History and Archives
Division, Phoenix
98-7684

109 Baseball at Luke
Arizona State Library,
Archives and Public Records,
History and Archives
Division, Phoenix
98-7690

110 El Tovar
Arizona State Library,
Archives and Public Records,
History and Archives
Division, Phoenix
98-7271

111 Cochise County Courthouse
Arizona State Library,
Archives and Public Records,
History and Archives
Division, Phoenix
96-4371

112 Luke Fighter Planes
Arizona State Library,
Archives and Public Records,
History and Archives
Division, Phoenix
00-0073

113 Rangers Reunion
Arizona State Library,
Archives and Public Records,
History and Archives
Division, Phoenix
96-2381

114 Governor Fannin Inauguration
Arizona State Library,
Archives and Public Records,
History and Archives
Division, Phoenix
97-8196

115 Glen Canyon Dam
Arizona State Library,
Archives and Public Records,
History and Archives
Division, Phoenix
97-6111

116 Carson Mesa
Arizona State Library,
Archives and Public Records,
History and Archives
Division, Phoenix
97-1701

117 Lake Havasu City
Arizona State Library,
Archives and Public Records,
History and Archives
Division, Phoenix
96-3895

118 Humphrey's Peak
Arizona State Library,
Archives and Public Records,
History and Archives
Division, Phoenix
96-3393

119 Bird Cage Interior
Arizona State Library,
Archives and Public Records,
History and Archives
Division, Phoenix
96-4348

120 Conn Workshop
Arizona State Library,
Archives and Public Records,
History and Archives
Division, Phoenix
03-5011a

Printed in the USA
CPSIA information can be obtained
at www.ICGtesting.com
JSHW072021140824
68134JS00042B/3727